Wartime Kiss

ESSAYS IN THE *Arts*

artime Kiss
*Visions of the Moment
in the 1940s*

ALEXANDER NEMEROV

Princeton University Press

Princeton and Oxford

Published by Princeton University Press, 41 William Street, Princeton,
New Jersey 08540
In the United Kingdom: Princeton University Press, 6 Oxford Street,
Woodstock, Oxfordshire OX20 1TW

press.princeton.edu

Jacket Photograph: *James Stewart and Olivia de Havilland on a picnic*, 1940.
© John Swope. Courtesy of the estate of John Swope, The Stewart Family, LLC.
and Ms. Olivia de Havilland

Library of Congress Cataloging-in-Publication Data
Nemerov, Alexander.
 Wartime kiss : visions of the moment in the 1940s / Alexander Nemerov.
 p. cm. — (Essays in the arts)
 Summary: "Wartime Kiss is a personal meditation on the haunting power of
American photographs and films from World War II and the later 1940s. Starting
with a powerful reinterpretation of one of the most famous photos of all time, Al-
fred Eisenstaedt's image of a sailor kissing a nurse in Times Square on V-J Day, Alex-
ander Nemerov goes on to examine an idiosyncratic collection of mostly obscure or
unknown images and movie episodes—from a photo of Jimmy Stewart and Olivia
de Havilland lying on a picnic blanket in the Santa Barbara hills to scenes from such
films as Twelve O'Clock High and Hold Back the Dawn. Erotically charged and
bearing traces of trauma even when they seem far removed from the war, these pho-
tos and scenes seem to hold out the promise of a palpable and emotional connection
to those years. Through a series of fascinating stories, Nemerov reveals the surprising
background of these bits of film and discovers unexpected connections between the
war and Hollywood, from an obsession with aviation to Anne Frank's love of the
movies. Beautifully written and illustrated, Wartime Kiss vividly evokes a world in
which Margaret Bourke-White could follow a heroic assignment photographing a
B-17 bombing mission over Tunis with a job in Hollywood documenting the film-
ing of a war movie. Ultimately this is a book about history as a sensuous experience,
a work as mysterious, indescribable, and affecting as a novel by W. G. Sebald"— Pro-
vided by publisher.
 Includes bibliographical references and index.
 ISBN 978-0-691-14578-5 (hardback)
 1. World War, 1939-1945—Photography. 2. Historiography and photography.
3. World War, 1939-1945—Motion pictures and the war. 4. Art and history.
5. Collective memory. 6. Nineteen forties. I. Title.
 D810.P4N46 2012
 940.53'73—dc23 2012026332
British Library Cataloging-in-Publication Data is available

This book has been composed in Garamond Premier Pro and Myriad Pro

Designed by Tracy Baldwin
Printed on acid-free paper. ∞
Printed in the United States of America

10 9 8 7 6 5 4 3 2 1

Contents

Wartime Kiss

Introduction

How do we remember the Second World War now? Often it comes to us in famous photographs and movie scenes from those years. A sailor plants a kiss on a nurse in Times Square on V-J Day. Jennifer Jones runs tearfully alongside Robert Walker's train as it darkly leaves the station in David O. Selznick's home-front magnum opus of 1944, *Since You Went Away*. The photographs carve out a piece of time, the films unfold a short sequence of set-piece locomotion. The photojournalistic precision of an instant, the melodramatic crescendo of a tearful goodbye: these are the set-pieces wherein all that was held precious, special, could be locked and shown to future generations as a truth of the times. In those years the moment was the medium.

This book takes the power of the moment seriously, but not in ways we might expect for an account of the Second World War. It starts with Eisenstaedt's photograph, but it is mostly about other moments from those years. The photo-

graphs and movie scenes you will find here are usually not so well known. A few are truly obscure. I have found these images sometimes by chance, and it is only my sensibility that has restored them to some reawakened life. I have chosen them because they feel to me like a disturbance on the surface of things, akin to what Roland Barthes describes as the *punctum* of a photograph—a piercing, wounding sensation without explanation—and because I believe (adapting Barthes to the practice of doing history) that the inexplicable wound is a means of coming into contact with the past. The trembling of these moments is maybe only so much personal projection, true, but then again it might be some breath of the past that has chosen me, or one of my students (I tell them to be aware of these moments), to be its host. Taken together, these moments do not provide an authoritative account but a patchwork of glimpses of that era. Yet in their ephemeral and random combination, brought together like a bouquet in my hand, they promise a recollection that is more sensuous, maybe more delightful and more mysterious, than an official history.

Maybe that is because this is a book about time on many levels. It is about the time between now and then, the current we will have to ride to get from here to there. It is also about the strange combination of then and now familiar to students of photography—the way a photograph brings a lost moment and person directly into our view, so that what *was* and what *is* coalesce in eerie combination. It is also about how each of the photographs and scenes I discuss conveys its own attitude about time. Some freeze it. Others suspend it. Some strive to be without it. Others nod and glance toward but utterly avoid the *terror* of time, the

infiniteness of death, while still others confront this slow rot with painful precision. Every moment unfolds with its own special temporal atmosphere. Remembering the war years means not only imagining particular moments but imagining the ecology of time—luxurious or nightmarish, sudden or suspended, narrow or infinite—within each one of them.

How does one write about these moments? This book tries to imagine a different way of writing history. The past emerges here in a scattershot of sound, like a radio dial turned from one end of the frequency to the other and back again, first fast, then slow, backward and forward. We hear less the honey of official slogans than the garbled eloquence of the hitherto unheard, the stitched sound of those who never got their say, whose stories this book sometimes tells. We hear too the beautiful tones of the famous, though in unaccustomed words. All have their moment, and sometimes the moments are so lyrically present that they hardly seem to be from the past. But in all cases there is no permanent coming to light and audibility, no sense of history as a preservation of the lost. Amid the gravelly crackling of the noise, whole worlds briefly appear, but the voices fall back to their corners, whorled in retreat. Moment to moment, the greeting of past and present is quick to come and go.

The historical writing that responds to these moments is as weightless as the moments themselves. Gravity is usually thought to be the historian's element, but butterfly-wing atmospherics slow-drawn in air are another form of historical recollection. Zephyrs provide the currents of displaced sensations, the lost and unlocked phantoms waiting to be written with as light a hand. The air becomes the medium

for being borne along, being inspired, by what is not there. I cannot believe that the past could just blow away, and I have decided that the wind that's taken it is what I'll write my history with.

When it is truly carried away, historical writing is a kind of flying.

Kissing in August 1945
Belita Jepson-Turner

He must have been in a hurry. Maybe he was out of breath. Alfred Eisenstaedt was running ahead of a sailor he had seen in Times Square. The sailor was kissing every woman who chanced in his path, and Eisenstaedt sensed an opportunity to make a photograph. The evening was historic: August 14, 1945, the Japanese were surrendering—the end of the Second World War was announced that night—and the kissing sailor was a good bet to sum up the joy of the occasion. What better American hero of the evening than this Davy Crockett of the spit-swappers? Eisenstaedt, a little man, looked over his shoulder as he ran, holding his Leica, mentally rejecting some of the photographs he might have made as he watched the sailor, also running, move amorously down the street. "Then suddenly, in a flash, I saw something white being grabbed," he recounted. "I turned around and clicked the moment the sailor kissed the nurse." Eisenstaedt took four photographs—"it was done within

a few seconds"—and one of them became famous after it was reproduced on a full page in the August 27 issue of *Life* magazine (fig. 1).

Eisenstaedt shows the sailor and nurse stuck in the squeeze of a historical moment he made it his business to portray. His picture, like the occasion, would be momentous. It would say all that there was to say on the subject of the end of World War Two that night in Times Square. Eisenstaedt had already done a feature for *Life* on wartime kisses in 1943, surreptitiously photographing tearful couples saying their goodbyes at Pennsylvania Station, and when he saw the sailor he must have known, as much as the sailor himself, just what he wanted. The four photographs he took correspond to the successive beats of the prolonged kiss. There would be no equivocation here, no reportorial nuance of the kind that, say, *PM* newspaper showed in its own V-J Day photograph of a kissing Times Square couple. In that picture the woman, kissed by the man, is simultaneously pulled away by a friend: "One girl tried to save friend who was getting kissed," says the caption. Another *PM* photograph struck a somber note: "Girls gathered around this marine at Times Square," reads the caption. "He said he felt solemn, thinking of buddies who would never return." But Eisenstaedt's image allows few cross purposes. The blistered and frazzled contours of experience are honed to the razor's edge of this one couple, the knife line of the nurse's stockings drawn so sharply against the pavement, the shark fin of negative space between her knees, the intuitive and clarified lines of a photographer so many years on the job, who knew just how to reduce, intensify, and sum up, for all the world and all time to see, what none of us then and

1

Alfred Eisenstaedt,

V-J Day Kiss,

Times Square, 1945.

Masters Collection,

Getty Images.

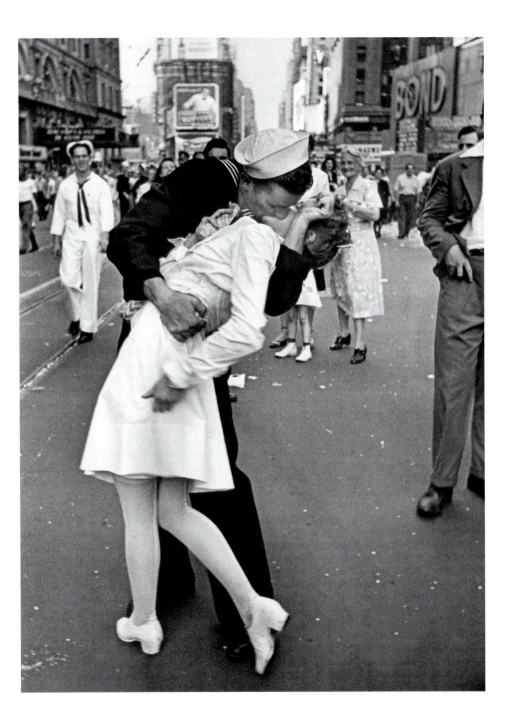

none of us now could ever ourselves agree to see was the way it was.

The sailor's act is violent as he steals his unsolicited kiss. His right hand clenches the woman's waist and his left hand curls into a near fist as he takes his pleasure, locking the woman's head into place. His nose bent against the woman's cheek, he seems to eat her face. Her own mouth and nose meanwhile disappear, leaving only a little bit of chin. Her right hand, holding her purse, crumples in the narrow space between their bodies. The "Bond" sign in the right background, a random yet purposeful detail, states the couple's patriotic clasp, the obligation to yield to this strutting man of morale, this big-fisted lothario of the spittle-strewn streets, lest he crumple in existential desolation for lack of the kiss his service demands. All around them, a similar aggression was breaking out. Between 7 p.m. on August 14th and 7 a.m. the following morning, 890 people in the city were treated for injuries, 130 of them requiring hospitalization. Fifty people were arrested for felonies, 78 automobiles were stolen, and 377 fire alarms were sounded (only 102 of them were false). Eisenstaedt's photograph suggests the wider mayhem.

So did *Life* in that August 27 issue. The feature accompanying the photographs of Eisenstaedt and others, a story of celebrations nationwide, notes how in Los Angeles "impromptu pedestrian parades and motor cavalcades whirled along" Hollywood Boulevard, "hindered only by hurled whiskey bottles, amorous drunks and collisions." In San Francisco drunken servicemen "defaced statues, overturned street cars, ripped down bond booths, [and] attacked girls," the riots causing more than a thousand casualties. The

many photographs of kissing couples in the *Life* feature, interspersed amid images of liquor-store looting and the like, give the happiness a chaotic feel. The dispassionate caption to Eisenstaedt's full-page photograph, "In New York's Times Square a white-clad girl clutches her purse and skirt as an uninhibited sailor plants his lips squarely on hers," is a far cry from the sheer pleasure the photograph has since been thought to show. The advent of peace could be dangerous.

V-J Day Kiss, Times Square intimates a still larger violence—that of the atomic bombs that ended the war, the first dropped on Hiroshima on August 6 and the second on Nagasaki on August 9. "The metropolis exploded its emotions . . . with atomic force," Alexander Fineberg wrote in the *New York Times* on August 15, describing the peace celebration. "The victory roar that greeted the announcement beat upon the eardrums until it numbed the senses. For twenty minutes wave after wave of that joyous roar surged forth."

The two people in Eisenstaedt's photograph celebrate because of the bomb, the triple-decker headline news of the mystery superweapon fresh in their minds. The readers of *Life*, opening the August 27 issue, had read accounts and seen photographs of the atomic destruction in the previous week's edition ("Hiroshima: Atom Bomb No. 1 Obliterated It," "Nagasaki: Atom Bomb No. 2 Disemboweled It"). The kissing couple belongs to the magazine's nuclear lexicon in those weeks, the discordant imagery of the bomb and its aftermath: "The people of the world, although thrilled by the prospect of peace, were shaken by the new weapon which had brought it about."

The couple's embrace anticipates the link between sexuality and atomic destruction—the kind found in the dropping of the bomb at Bikini Atoll on July 1, 1946, heavily featured in *Life*'s pages, that led to the naming of the new two-piece swimsuit introduced that year, or the kind featured in Stanley Kubrick's 1964 film *Dr. Strangelove*. Accordingly, *Life*'s mix of bombs and sex set the limit of the couple's love. Violence is the medium of their encounter, the grace and arc and weaponry of it. Sheltering in the explosive passion of this new atomic world, maybe the couple feels a frisson akin to the metallic taste the crew of the *Enola Gay* felt in their mouths when the bomb went off, so many thousands of feet below.

The flash was the sudden soul of that moment. "There was a terrific flash of light, even in the daytime," an *Enola Gay* crewmember said in *Life*. Or, as John Hersey opens *Hiroshima*, published in 1946, "At exactly fifteen minutes past eight in the morning, on August 6, 1945, Japanese time, at the moment when the atomic bomb flashed above Hiroshima, Miss Toshiko Sasaki, a clerk in the personnel department of the East Asia Tin Works, had just sat down at her place in the plant office and was turning her head to speak to the girl at the next desk." News of peace, too, was a flash—"the magic words," as the *Times* put it, "flashed on the moving electric sign of the Times Tower, at 7:03 p.m."

The sailor, kissing the nurse right around that minute, assumed this form of time, the flash, so much in favor then (even if Eisenstaedt did not literally make a flash photograph). The sailor personifies all that is momentary, as if the flash were not an envelope of time that held his actions so much as a force that inhabited and drew his contours,

10

the gel and quicksilver without which he would collapse to the pavement like so many sticks and straws, a jumble of depleted matting and flattened fabric—living in the moment!—and without which Eisenstaedt, too, would be at a loss. "Then suddenly, in a flash, I saw something white being grabbed."

The photograph and the bomb are both explosions of the instant. Think of the street photographs allegedly taken by the Hiroshima bomb itself, as described by Hersey: "a painter on a ladder was monumentalized in a kind of bas-relief on the stone façade of a bank building"; "a man and his cart on the bridge . . . were cast down in an embossed shadow which made it clear that the man was about to whip his horse." Hersey aligns his own writing with the photographic flash of the bomb, describing Toshiko Sasaki turning to the girl next to her at the moment the bomb explodes as the book starts: Hersey, too, like the bomb, portrays an instant. The photograph nullifies the world around it, Eduardo Cadava writes, describing a photo of a bombed-out bookstore in London in 1940 during the Blitz. Such photographs cancel the historical worlds they come from, blasting into the present as unreadable fragments of a history to which we have no other access except in such permanently blinded forms. Eisenstaedt's moment is no less explosive, but the clarity of his blast, like Hersey's, aims for a permanent historical illumination.

And if it was this way, and if it wasn't this way, how fitting that the photograph's own insistence that all be tight, all be clasped, all be closed-down into one heraldic emblem out of time, a timeless moment, an immortal moment, is the very thing that makes the picture look dated. The cen-

trality of this consummation, there where the street splits, should make us distrustful of time having been so ceremonially arrested. The sprig of the bounding stag clutching the damsel against a field of tar—is this the blazon of the dented shield in our museums? Was this the war? Was this the war's end? Does this image give us truly something to remember that time by?

The cover of the August 27 issue of *Life* offers an alternative (fig. 2). Made by a *Life* staff photographer named Walter Sanders, the image shows the ballet swimmer Belita Jepson-Turner performing one of her maneuvers at the Town House pool in Los Angeles. Sanders's photograph, taken through an underwater window, has nothing to do with the Times Square kiss contained in the same issue. Or does it?

Sanders's photograph is itself a V-J Day image. Belita Jepson-Turner's grace speaks of peace, of peacefulness, appropriate for the cover of a magazine released less than two weeks after the war's end. At the same time it is no less topical as an image of destruction. She descends like a bomb, like the new weapon released over Hiroshima on August 6, dropped from the *Enola Gay*, that B-29 with a woman's name whose pin-up art (had that plane featured any) might have resembled Jepson-Turner's bomber pin-up pose in *Life*. The relation between Sanders's photograph and Eisenstaedt's comes across visually as well. The two women share not only comparable arcs and swoons and eroticism but an identical scale on the page. Jepson-Turner is ten inches long from her toes to her nose and the nurse, whose name was Edith Shain, is nine and a half inches from her left shoe-tip to her forehead.

2

Walter Sanders,

Ballet Swimmer,

cover of *Life*

magazine,

August 27, 1945.

Time & Life Pictures,

Getty Images.

LIFE

BALLET SWIMMER

AUGUST 27, 1945 **10** CENTS
BY SUBSCRIPTION: TWO YEARS $8.50

I doubt anyone saw or bothered with any of these relations at the time the issue came out, or ever since. They are without weight. If we were to make anything of them at all, perhaps it would be to say that together the two pictures show the house style of *Life* magazine—a certain dependable visual code, heavily calculated, calling for erotic figures, most often women, and imaged at a size sufficient to fill the fourteen-inch vertical and ten-and-a-quarter-inch horizontal dimensions of a *Life* page. According to this house code, the women would be caught in the precision of their gambols, pure but with a little filth thrown in, a little confetti in the chlorine, in just the right antiseptic inoculations, lust delivered to the reader in premeasured dosages.

But that is only partly an explanation. Sanders's photograph not only relates to Eisenstaedt's, it is an alternative. Sanders had himself taken a photograph of a kissing V-J Day couple, included in the same suite of photographs as Eisenstaedt's in the August 27 issue. It shows a woman in high heels languidly stretching back across the hood of a jeep, holding a little American flag, and accepting a kiss from a soldier. That woman is a cross between Jepson-Turner in her pool and Shain in Times Square: the same elegant extension of body as Jepson-Turner, the same military kiss as Shain (albeit without as much coercive force). But at the Town House pool Jepson-Turner is free and alone, almost as though she were the woman leaning back on the jeep, except now minus the carousing soldier, or as though she were Edith Shain, except without the sailor, released from that picture's lockdown of calculations.

Jepson-Turner is also an alternative definition of the historical moment—the month of the atomic bombs.

Sanders's photograph contradicts Eisenstaedt's claim that history becomes clear to us in a picture that freezes time. Jepson-Turner, by contrast, is suspended, caught in an ongoing moment. Neither sinking nor swimming, cut off from life and in her own world, she floats in an element outside time. Yes, she may be compassed by calendar and cost—she seems to note the date and price of that week's issue, putting her face right there where this information is, as though the magazine's price, 10 cents, were a dime that had floated to the bottom of the pool. And yes, her time there in the pool is finite: she can hold her breath for only ten seconds, an article inside the magazine notes. But Sanders's photograph suggests that historical moments reveal themselves to us in an eternity of slow-motion becoming, each one a kind of infinite dream, rather than in static and frozen instants.

If so, Sanders's photograph suggests that historical moments have much in common with aesthetic moments. Time in an aesthetic moment is "racked into a dread armistice," to use Thomas De Quincey's unsurpassed description:

> We must be made sensible that the world of ordinary life is suddenly arrested—laid asleep— tranced— racked into a dread armistice; time must be annihilated; relation to things without abolished; and all must pass self-withdrawn into a deep syncope and suspension of earthly passion.

In such a moment the lost world of the past appears to the historian much as the visible world is revealed to the poet. In an infinite or eternal moment, a space you could walk (or swim) around in seemingly forever, taking your time, not-

ing the details—the faces, the hands, the skin, the walls, the trees, whatever should be visible before your eyes—what you would see would flex to a widest point and contract to a narrow tip, expanding and contracting almost with one's own breath.

In this swimming element of time, historical detail is present without being seen. Maria Belita Gladys Olive Lyne Jepson-Turner, born in England in 1923, skated at age twelve for Great Britain at the 1936 Olympics in Garmisch-Partenkirchen, where she competed in the women's singles event against Hitler's favorite, Norway's Sonja Henie, who successfully defended her Olympic title. (Jepson-Turner finished sixteenth in a field of twenty-six.) Nazi soldiers were everywhere during the games, Jepson-Turner recalled years later, and all athletes were required to give Heil Hitler salutes. Like Henie, Jepson-Turner came to Hollywood soon after, arriving with her mother Queenie (who had started her daughter skating at age two) to begin an acting career that included a few films, including *Silver Skates* (1943) and *Lady, Let's Dance* (1944) by the time of her *Life* cover. She was a dancer, too, and three years before the cover she had taken up balletic underwater swimming, partly to heal her back, which she had injured in a fall during a skating performance at Covent Garden.

The photograph swims with other things it does not show. The name Belita comes from an Argentine railroad station and ranch called "La Belita," built by Jepson-Turner's great-grandfather G. W. Drabble, who had arrived in Buenos Aires from Manchester, England, in 1848 to sell cotton and remained there, becoming one of the most powerful Britons in Argentina. As an article about the

16

skater put it in 1946, Drabble acquired "thousands of acres of the best land in the vicinity of Buenos Aires," built five livestock ranches on his properties, then built railroads to the ranches. Eventually, in the 1880s, he established a major trade in the transportation of frozen Argentine mutton back to England.

Belita grew up on the huge family estate of Garlogs, at Nether Wallop, Hampshire, where the grounds covered four villages and the main house contained thirty bed-rooms. So large was the house that as children she and her two older brothers Bertram and Richard competed against each other in miniature racecars on a track they had made in the hallways. When the war began, she was in Los Angeles and unable to get back to England. Both her brothers fought in North Africa under General Montgomery, and each was wounded.

The suspended moment does not portray any of this—dynamited Argentine hills; a twelve-year-old in Garmisch-Partenkirchen; the brothers in the war—but it holds such violent histories invisibly. As a *Life* caption notes, "The picture does not show either her volatile personality or the two scars which she got by running through a glass door one day when she was particularly angry."

Sanders, too, had a history that his photograph shows by not showing. A German émigré in Los Angeles, he had fled Berlin in 1936, in the midst of a successful photography career, after his "non-Aryan activity" had been repeatedly criticized by an SS newspaper. In 1946, the year after his photograph of Jepson-Turner appeared on the cover, Sanders returned to Berlin, finding his old residence at No. 6 Kluckstrasse. A feature in the November 11, 1946 issue of

Life, illustrated by Sanders's own photographs, details his homecoming. "I could not go in," he wrote, describing the scene at the remains of his house, ruined by bombing raids and artillery fire. "Huge piles of rubble blocked the way. But through shell holes and empty windows I could see what was once my living room. A twisted radiator was still hanging under one window."

In Los Angeles during the war, by contrast, Sanders might have felt like many of his fellow German émigrés— that he was in a place without history. His photograph of Jepson-Turner might even be a surreptitious critique of this history-less place, a deadpan portrayal of the filtered lust and scheduled spontaneity of American entertainment, here given to the bosses themselves as a mirror reflection of their determined vacuity and healthful amnesia. In one of his "Hollywood Elegies," Sanders's fellow German émigré Bertolt Brecht wrote that "The city is named after the angels / And you meet angels on every hand." In the photograph Jepson-Turner is maybe such a superficial angel, a Brechtian figure of Los Angeles there in her pool (the angels "feed the writers in their swimming pools every morning," wrote Brecht), yet she might as easily be an angel of remembering, floating outside time as the embodiment of memory itself. At the time he took it, Sanders could only guess what his home city looked like, at who would be alive or dead. He too, like Jepson-Turner, was in limbo.

Suspense is their mutual element. In 1946 Jepson-Turner would star in a film called *Suspense*, the one of her movies she was most proud of. In this rare ice-skating *noir*, she plays a top-billed skater named Roberta Elva whose nightly challenge is to jump through a steel hoop studded with

3
Roberta Elva
(Belita Jepson-Turner)
jumping through
the hoop of knives
in *Suspense* (1946).

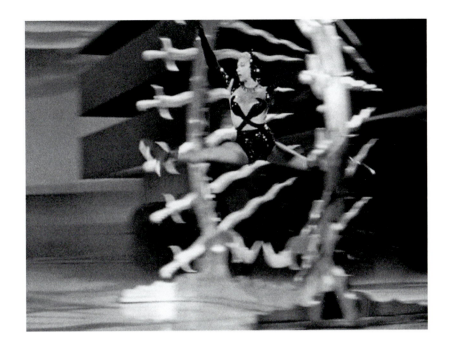

huge swords (fig. 3). The jump is the film's big moment of suspense, and it shares qualities with Sanders's photograph. The hoop of shiny blades repeats the patterned glow of the swimming pool, an effect emphasized in the film, where the blades cast their shimmering reflections on the ice. The two scintillations, however, give different definitions of the suspended moment.

The sun-ray knives solidify the ineffable energies of dilated time, as if those energies could be turned into a stable and eye-catching prop, slivering the seconds like the ice skates they are some monstrous representation of. Frozen suspense is a coercive marriage ceremony, the hoop a ring of phallic fate, a sadistic emblem of Roberta as the object of desire (fig. 4). Roberta is loved by two men—her husband

(not pictured) and the tough guy Joe (Barry Sullivan), designer of the hoop, shown here checking the blades in company with his assistant Harry (Eugene Pallette). The coercion goes against Belita's affect in the film, where her understated acting, refined accent and diction, and regally muscular athlete's body counter the other characters' quick talk and the sleazy snap of the plot. "She seems, frankly, like a circus animal—a superior creature trapped in a cage for the amusement of lesser beings," notes the film historian Eddie Muller. But there she is, caught in the bladed prison of a mandated excitement, married to the glitzy allure of a moment so frozen it goes on being a crystallization of time even after the rink's doors have closed for the evening and there is no one to jump through it. Forever and ever, it is the eternal circle as conceived by the props department, a moment to last always.

The water of the pool, by contrast, is all wash. Lacking structure, it suggests that the moment is a sieve that simultaneously drains and fills. There is nothing to grasp amid these bayonets of light, but that is the pleasure, the openness, and the freedom of this other form of suspended time. Jepson-Turner still performs a scintillating routine for an audience, but she operates in this dreamier atmosphere as if alone. Her recollection that she did not even know a photographer was present when Sanders made the picture is clearly wrong— the interior of the magazine includes many photographs of her posing for the man at the underwater window—but in spirit it is right. In Sanders's photograph, Belita inhabits a suspension of time as regally removed as herself.

The past in such moments is a flow, a dreamy and untrustworthy medium, with qualities of hocus-pocus and re-

4

Roberta (Jepson-Turner), Harry (Eugene Pallette), and Joe (Barry Sullivan) in *Suspense*. Photofest.

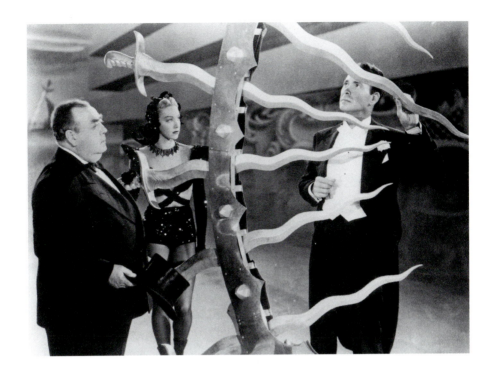

ligious revelation. Jepson-Turner on the *Life* cover is not an insect in amber but a figure in a crystal ball. She floats like a vision, a hallucination, in the shimmer of aquatic luminosity that streaks her thighs and calves. Her element is the mirage, the water as weightless as air, where the haloes seem tricks of the sun, the image, or both. Like the Madonna appearing in a freshet of gasoline, she is a vernacular apparition, inviting faith, not to be trusted. In the suspended historical moment that comes to us in a sensuous vision, we do not know what to believe, and we cannot be sure of what we see.

Sanders's photograph portrays the medium of suspended time, but even this unusually fluid image must freeze the

phenomenon, providing us only with a good guide and not with the phenomenon itself. The past in a suspended moment comes to us in a combination of visibility and invisibility, presence and absence, that takes the form of a reversal. It is not the hand, and it is not the glove that the hand once wore. It is not even the vibrating sheath of air displaced as the gloved hand once swung through space. It is that sheath of air *as it assumes the form of the hand that once swung through it.* Historical actions displace thin air, which after the commotion takes the shape of the actions themselves. This is why at historic sites we can be touched, and changed, by what is not there. This is why the absolute blankness and emptiness of a place can feel like a redoubling of those who once were present in it. Long-ago events and people array themselves in effigies stroked and caressed out of vapors so fine it would tax the powers of even a believer to see them. No ghost hunter with his hobgoblin Geiger counter is ever going to find them because the ghost hunters don't know that what you set your traps for, what you lower the booms of your microphone down into the very grass and dirt to hear, is the buzz of nothing that is the past's objective form. In Sanders's photograph, Jepson-Turner is crisply outlined against the water, but the shimmer of the pool is her true image, the medium in which the past appears in a suspended moment. How is 1945 present to us now? Not there anymore, her time long since gone, Jepson-Turner appears as a scar on the surface of the air.

Sleeping Beauty
Olivia de Havilland

In 1940 a photographer named John Swope took a picture of James Stewart and Olivia de Havilland on a picnic (fig. 5). The two movie stars relax in a graceful, unselfconscious way, reclining on a blanket with a portable phonograph behind them on the grass. I encountered the photograph by chance, in a recent book of Swope's work I saw in a bookstore. Of all the very good pictures I saw in that book—a revelation to me, since I did not know of Swope before—the one of Stewart and de Havilland made the strongest impression. In part this is because of de Havilland, whom I've always liked, beautiful in her angora sweater. But it is also because of the special contentment of the whole scene.

I did some checking and made some phone calls and before long I was talking with Mark Swope, John Swope's son, and soon after I was at Mark's house in Los Angeles. There Mark has drawer upon drawer of his father's negatives, neatly sleeved and labeled. Soon, looking through

one drawer, he found a set labeled Santa Barbara picnic, which he removed in strips from their sleeves and laid down on his scanner, creating positives of all the picnic photographs his father took that day. One shows Stewart and de Havilland ascending the hill, another, Stewart setting the platter of a record on the spiffy portable phonograph. Others depict Stewart climbing a nearby tree, de Havilland watching and smiling, then joining Stewart in an angle of trunk and branch. And there too was the photograph that first drew me.

"Contentment" is a word for that scene, but the photograph's sense of time is what most attracted me. What kind of time does it refer to? In one sense, it is ordinary historical time. Stewart and de Havilland were at a specific point in their careers. Stewart had just starred in *Mr. Smith Goes to Washington*, the film that helped make him a star just a few years after he had arrived in Hollywood. His date, de Havilland, had just played what would always be her most famous role, as Melanie, Ashley Wilkes's wife, in *Gone with the Wind*. Stewart had met her in December 1939 when de Havilland's agent, Leland Hayward, helped arrange for him to escort the actress to the New York premiere of the Civil War epic. Swope knew both of them because he had lived with Stewart and another roommate, Henry Fonda, in a house in Brentwood—the three men were great friends— and because he worked for Hayward, who had just written the enthusiastic preface to Swope's impressive book of behind-the-scenes photographs, *Camera over Hollywood*, published in 1939. But in another sense, apart from this chronology, the photograph aspires to show a time without time. It does so by referring to a film no less important to

5

John Swope,

James Stewart and

Olivia de Havilland,

1940. Copyright

John Swope Trust.

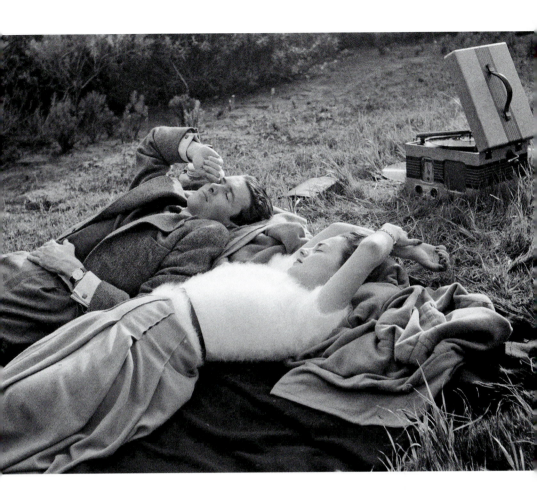

de Havilland than *Gone with the Wind*: the 1935 Max Rein-
hardt production of *A Midsummer Night's Dream*.

Swope's photograph recalls a scene in the film when de
Havilland as Hermia and Dick Powell as Lysander pause
in the woods a mile outside Athens (fig. 6). De Havilland
got the role, her first, after she came to Hollywood in 1934
at age seventeen from her hometown, Saratoga, California,
and secured an understudy's role in the stage production of

A Midsummer Night's Dream directed by Reinhardt, the fabled Austrian theater director there to stage his celebrated version of the play. Given a chance to step into the role of Hermia, de Havilland excelled in the magical outdoor production with its sylvan setting of actual oak, elm, and aspen trees, impressing the thousands nightly in attendance at the Hollywood Bowl. Studio executive Jack Warner saw her perform and signed her the next day to play Hermia in the film version of *Dream* that Reinhardt was to direct for him. Her movie career began.

In the scene where Hermia and Lysander stop in the woods, ordinary time comes to some sweet pause. They have left Athens to elope, their plans to marry having been rejected by Hermia's father, Egeus, who wishes his daughter to marry Demetrius. Tired and lost, the lovers decide to rest for the night, and lying down upon the earth they acknowledge death only to make light of it. "Your love ne'r alter until your sweet life end," says Hermia, sweetly. Powell's Lysander rejoins, in mock pathos: "And then end life, when I end loyalty," before adding with earnest affection: "Sleep, give you all his rest." Amid their batty and chaste talk of love, the couple speaks of life ending, and they do so on a ground that has a faint funereal implication. But they plainly do not know what they are speaking about. As Reinhardt's direction brings out, they cannot register what they are saying, because it is impossible for someone so young in such an enchanted state to realize their mortality, and so death is swerved to sleep, and all is happy, and all is well. In Swope's photograph, we see two young movie stars (Stewart was 32 in 1940, de Havilland 24) on top of their profession, on top of the world, in love with one another, in

6

Lysander (Dick Powell) and Hermia (Olivia de Havilland) in *A Midsummer Night's Dream* (1935). Margaret Herrick Library.

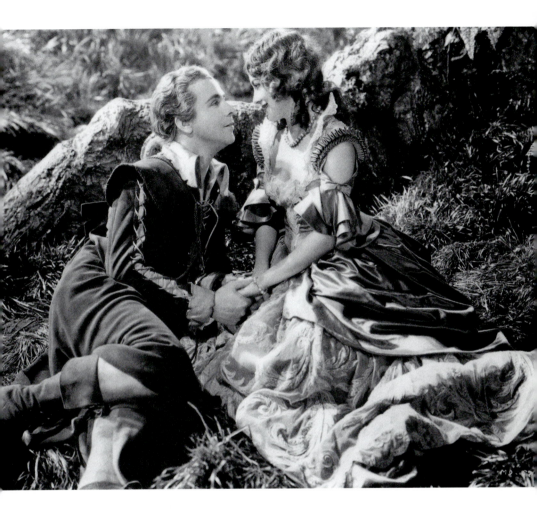

the close and trusted company of their good friend. There they need not, should not, cannot think their own deaths. They close their eyes.

And Stewart presses his right hand to his right eye. That gesture, too, evokes *A Midsummer Night's Dream*. In the movie, Mickey Rooney plays Puck, who as the attendant to Oberon, King of the Fairies, squeezes a potion of love-

juice on the eyes of Lysander soon after he has fallen asleep (fig. 7), the first of several such moments in the play. These anointments tell us who is falling in love with whom (Lysander wakes to love Helena instead of Hermia; later, more drops will restore his love for Hermia). Symbolically, however, these potions are about an enchantment of vision, implicitly that brought on by art itself. If the play famously likens its sounds to the baying of the Spartan hounds—"so musical a discord, such sweet thunder"—it conceives the spectacle of a night's performance as a beguilement of the eyes. The show is brief, the effect lasts. "It seems to me," says Demetrius upon waking, "That yet we sleep, we dream." Or as Bottom proclaims after he too wakes up, "I have had a dream, past the wit of man to say what dream it was. . . . I will get Peter Quince to write a ballad of this dream; it shall be called 'Bottom's Dream,' because it hath no bottom." Art stretches out, attaining an infinite dreamy depth; in it the daily world goes to sleep, and we see, in that special place beyond ordinary concerns, some enchantment outside of time. In Swope's photograph, the happenstance of Stewart's gesture to his eye—sleepy, incidental as it may be—is a meaningful match to Shakespeare's and Reinhardt's aim to enchant our eyes. There on the hills, some alternate order obtains; the photograph works its charm.

Passing time appears nonetheless. Stewart wears a watch on his left wrist, and his right hand, his enchanted hand, repeats the angle of the needle arm of the portable phonograph. The record on the platter appears to have finished playing—the needle has stopped squibbing against the inner circle of the disc; the song has ended. So have other songs. Another record sits to the side on the grass, perhaps

placed there after its music, too, has sounded. Stewart wipes his eye, maybe because he must turn around, reach back, and change the tune. Maybe on that boxy axis—the one made by the phonograph container at one end and the actor's wrist-watch, white shirtsleeve, and cuff link on the other—the spinning of the record and the turning of the watch's hands encompass an altogether timely moment after all. The song over, the hour (who knows) getting late, the two may think it's time to go.

But maybe the phonograph is the sign of the ongoing moment after all. Recorded music, yes, is canned sound, as

7
Lysander (Powell) and Puck (Mickey Rooney) in *A Midsummer Night's Dream*. Margaret Herrick Library.

the cultural historian Jonathan Sterne calls it, an audible past, the dead or at least the *not there* speaking as though they were present, the needle stuttering like a candle flame. But recorded music also allows lost time an ongoing life. The photograph, too, aspires to no inscription of *Et in Arcadia Ego* but instead unfolds a moment meant to last, indeed a moment (as a photograph has a way of doing) that is lasting to this day—the music having ended but still in the air. The image is a box that itself still plays, and the phonograph is a little allegory, there in the upper right corner, of all that photography itself can do. So Stewart's arm, suspended in the elixir pose of a dream, suggests a moment that in ending never ends. And so when I first saw and was enchanted by this picture, and when Mark Swope pulled the negative from its sleeve, lost time did play again: as though, even, no time here had ever been lost.

Her eyes closed too, de Havilland remains in that infinite moment. Mitchell Leisen, who would be one of her favorite film directors in the 1940s, affectionately called her "Moonglow," a fitting *Midsummer Night's Dream*-like term for how we see her in Swope's photograph. Leisen referred to how de Havilland would become so entranced by her characters that she seemed far away from her immediate surroundings: "She's so absorbed in the things she's doing that she walks around the set as if in a golden fog." On their picnic de Havilland and Stewart both knew, always, where the camera was—how could these movie actors not?—and I am sure she kept the eagle eye in her innermost head on where Swope was at any given moment, but she also seems genuinely forgetful of the lens, as if in one of her moonglow trances.

That absorption, moreover, is a type of lightness—a weightlessness—that is itself outside time. Moonlight is the element of *A Midsummer Night's Dream*. The glow of the satellite makes the play's world go round, offering a range of magical effects for the actors to draw upon, as if it were a raw material to be bent into shapes or spread like twinkling dust, and de Havilland's moonbeams are the most lyrically light of all. When Titania tells her fairies to attend to Bottom, to "pluck the wings from painted butterflies / To fan the moonbeams from his sleeping eyes," we have a fit sign for de Havilland's lightness. The film version of *A Midsummer Night's Dream* required a thousand-pound moonbeam about fifty feet long, hoisted into position by a tractor, as part of the forest setting, but de Havilland was a more airy phenomenon, maybe ever since she cavorted around the Saratoga glades as Puck in a local production of 1934. When years later the director William Wyler became frustrated with de Havilland for failing to get a scene in *The Heiress* right—she was required to climb a steep stairway while holding a suitcase, but the suitcase, being a prop, was empty, and she didn't seem to struggle with it enough for Wyler's taste—the director's frustration (he finally loaded up the suitcase to make it properly heavy) allegorized the question of weight and weightlessness—weighty roles and light ones, gravity and airiness—that characterized de Havilland's career.

Reinhardt and Leisen knew that a certain lightness made the actress special. When she settles into sleep near Lysander, Hermia is made of the beams of the moon, a silver light on the ground (fig. 8). In Swope's photograph, too, de Havilland aspires to be an enchanted vision. Maybe it is

Olivia de Havilland

8

Hermia
(de Havilland) asleep
in *A Midsummer
Night's Dream.*

her cloudy sweater that gives this effect, but she appears to have lost the sense of being a weighted person on the earth and to have become, unselfconsciously, the weightless rays that make her float. This lightness was another way to be outside time.

But to be outside time was not easy in Hollywood. In 1943 de Havilland starred in an RKO film called *Government Girl* in which she plays the feisty and loyal secretary to a Washington newcomer, a hardworking but naïve industrialist aiming to increase bomber production during the Second World War. A still shows de Havilland's character, Elizabeth Allard, pointing to a chart while her boss, Mr. Browne, played by Sonny Tufts, looks on, the two of them posing beneath a large wartime slogan, "Time Is Short" (fig. 9). The film is

noteworthy now not on its own merits—it is a conventional piece of wartime propaganda—but because it was the last one de Havilland completed before she legally challenged the temporal duration of Hollywood contracts. Time could be short in Hollywood—the drive to complete films in the shortest possible period—but it could also be long, way too long, and it was this length that de Havilland contested.

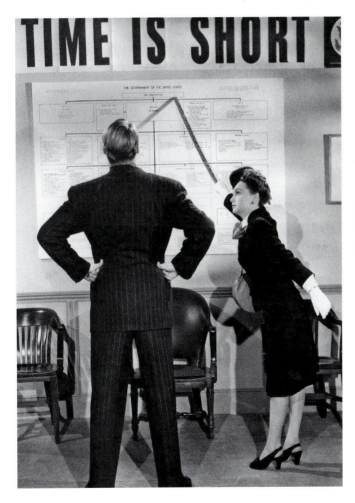

9
Ed Browne (Sonny Tufts) and Elizabeth Allard (de Havilland) in *Government Girl* (1943). Photofest.

When she signed with Warner Brothers for *A Midsummer Night's Dream*, her contract was for seven years, the Hollywood standard. The industry had decided upon this duration because it was the maximum period allowable for labor contracts according to California law. There was a catch, though, a way for the studios to get more from their performers. If an actor or actress was suspended, as they could be for refusing to make a studio-assigned film (the performers typically having little say in which films they were cast), their weeks in suspension were not counted. The seven-year clock stopped during those times. By May 1943, when she began work on *Government Girl*, having been loaned to RKO for the purpose, de Havilland's original seven-year Warner Brothers contract should have been winding down. But she had accumulated twenty-five weeks of suspensions without pay, the penalty for refusing to perform in certain films assigned to her by the studio. Therefore, once she completed filming in August, she met with her attorney and they filed suit, disputing the studio's right to suspend time and employ her beyond the seven years stipulated by California law.

She won the suit in November, thus liberating herself from studio time, but Jack Warner fought hard to force her to continue playing the up-to-the-minute roles (like Elizabeth Allard in *Government Girl*) that she sometimes turned down. Warner's lawyers had lost the case but now they appealed, shifting the force of their argument from the contractual time period to de Havilland's allegedly poor behavior as an employee, her high-handed refusal to play parts not up to the standard of Melanie in *Gone with the Wind*. She won again, and though Warner appealed the case to the

Supreme Court of California, that court refused to review it, allowing the judgment of the two lower courts to stand. The actress had been blackballed during the whole lengthy suit ("Court Denies de Havilland Plea to Work," ran a *Los Angeles Times* headline on September 21, 1944, more than a year after her last employment), but she emerged able to choose her own roles. And in 1946 she won her first Oscar for her role in Leisen's *To Each His Own*, her first film after the lawsuit.

Back in 1943 *Government Girl* was an allegory of all the ways "Moonglow" could be held to account by her studio bosses. Like her character Elizabeth Allard, de Havilland was an employee who was really running the show. Her boss in the film, Mr. Browne, is clueless and benefits from her direction, as we see in the photograph. During filming, de Havilland played a joke on Sonny Tufts, giving him a spare bag of her fan mail after she heard he was sad about having so little himself. She knew who was the star attraction—indeed who helped to make *Government Girl* a big hit in 1943. But the role epitomized the timely, topical parts so ill suited to her ethereal temperament, her wish for roles outside time. Watching de Havilland throw darts at caricatures of Hitler and Tojo, as she does in that film, is to view scenes made only for that historical moment, only for those years ("Time Is Short"), when a poke in the eye or a good stab at a statistical chart might produce the right cackle, the right kick in the back of the seat of the guy in front of you at the movie theater, whose very popcorn-spilling happiness bore the aggressive and defiant stamp of disposability. No one will care about this in the future, I cannot think beyond the moment—who cares?

Each studio had its own repressive standard for appealing to the moment, and de Havilland was a connoisseur of the different regimes. "Warners was like a vast prison," she said in 1946, "with Jack Warner the head keeper and we the inmates. . . . Metro always struck me as being a benevolent monarchy, with King Louis B. Mayer at the top and strata of dukes, duchesses, earls, and knights beneath. If one was a good person and played the game right he got promoted; but if he got in disfavor he might be just as suddenly demoted and fade out of sight. . . . David Selznick's, on the other hand, seems like a state department, with the head of the studio grooming all the members for good will. . . . I've never worked at 20th Century, but it's always impressed me as a loose military organization, with Col. Darryl Zanuck as commanding officer and the lesser ranks graduating downward." *Government Girl* was a parable of at least three of these powers—military, government, and prison.

In Swope's photograph, taken while she was in the middle of her Warners contract, de Havilland is on her own time, which seems to be no time at all. Recorded in Swope's photographs, the pedestrian journey to their picnic spot that day started with the slow stroll up the hill, then a spreading of the blanket in the tall grass, the unpacking of the hamper, and the eating of the meal. Stewart climbs the tree, perches in the branches, Olivia follows, a little reluctantly. Swope photographs her from above, from the neck up, framed against the blanket and grass, first her right hand over her forehead, then her left forearm. She is smiling in both pictures, laughing really, stunningly beautiful, her eyes crinkling in the sun.

The sequence unfolds in time, a forgotten episode. The tree climbing savors of period comedy, "the zany Marx brothers type of humor, wholly irreverent and illogical," that de Havilland said in 1940 she liked so much about Swope. The relationship, too, quickly became a thing of the past—Stewart and de Havilland stopped seeing each other by 1941. But the image of them lying together revolves to some other rhythm. The angle of their bodies, sloping out of the photograph at lower left, matches the slant of hill extending from upper right to out of the picture at middle left. Stewart and de Havilland seem poised and aslant the slowly turning globe itself, sloping their backs to the ball, as though they could feel the movement of it in their bodies, turning to the drowsiness of one eternal moment on earth.

Swope's photograph owes its timeless feel to another factor central to the lives of Stewart, de Havilland, and Swope himself. This is their common love of airplanes, a fact not immediately apparent in the photograph, except in a detail we might not notice at first: the way Stewart and de Havilland face the sky. For each of them, flying was a way to be exhilaratingly out of reach of the world. Even when aviation became the source of global violence on an unprecedented scale, as it did increasingly in the years after 1940, propeller-driven flight retained for all three an air of enchantment, a quality of piloting one's course beyond ordinary daily life.

Stewart learned to fly by 1936, not long after he signed his contract with MGM. At the same time he continued his boyhood hobby of building model airplanes. Often he would go out into a remote parched area with his room-

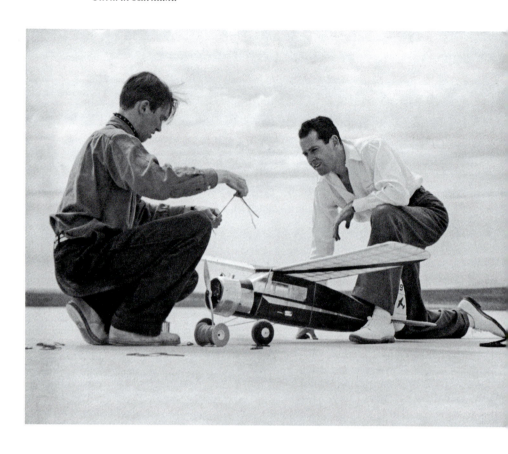

John Swope,

James Stewart and

Henry Fonda with

Model Airplane,

ca. 1936. Copyright

John Swope Trust.

mates, Fonda and Swope, where, according to Mark Swope, the men would spend hours in wordless rapport setting up and flying these models (fig. 10). Another Swope photograph shows Stewart, tall, cool, a sun-rag on his head, wearing sunglasses, contemplating his plane, its wings not yet attached, as he prepares it for flight (fig. 11). This boy-man of aviation—a gangly guy who on his nineteenth birthday in the small town of Indiana, Pennsylvania, where he grew up, had avidly charted Charles Lindbergh's transatlantic flight in 1927—was halfway between adolescent awe and

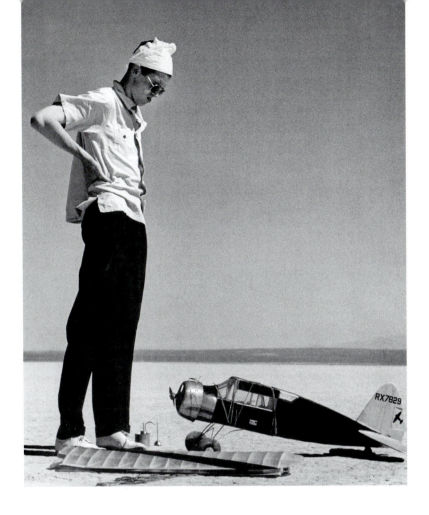

II

John Swope,

James Stewart with

Model Airplane, 1940.

Copyright John Swope

Trust.

wartime bravery when Swope photographed him. Planes like the little one he stares at were, in one sense, a sign of the increasingly militaristic times. To be "air-minded," in the argot of the 1930s, was not only to be a flying enthusiast but to be someone who understood the strategic importance of airplanes in the impending war that many people expected the United States would fight. Stewart had taken one of his airplane models with him to Hollywood in a custom-built case that looked to passengers and conductors like it held a machine gun, an unnerving package and a fit sign of

the violent implications of aviation then. During the war, Stewart flew B-17s on many bombing missions over Nazi targets, earning a Distinguished Flying Cross for his bravery, and was shaken by what he saw. But he always remained enamored of aviation in a more innocent way, with the kind of enthusiasm we see in Swope's photographs, and in 1957 Stewart got a role he had long coveted, playing Lindbergh in *The Spirit of St. Louis*.

Swope was a pilot, too. Born in August 1908, three months after Stewart, he was one of the air-minded generation that delighted in the pleasures of flight while sensing its strategic wartime uses. The son of Gerard Swope, the president of General Electric, he used his wealth to help establish Thunderbird Field in Glendale, Arizona, going into the venture with Stewart, Fonda, and Leland Hayward, among other investors. Completed early in 1941, the airstrip was a training ground for army fliers: Air Corps Chief Hap Arnold, anticipating a war but unable to appropriate money for wartime purposes, relied on Swope, Stewart, and the other investors to fund construction and initial operations. Swope became a flying instructor at a second Thunderbird Field in Scottsdale, eventually becoming the director and superintendent of operations, and in 1942 he collaborated with John Steinbeck in a book called *Bombs Away*, detailing the training of cadets at Thunderbird and containing sixty of his photographs.

Olivia de Havilland was no less thrilled by airplanes. Her romantic interest just prior to Stewart was Howard Hughes, who flew around the world from July 10–14, 1938, and who later that year phoned her for a date, the intro-

duction having been arranged by a mutual friend, the Hollywood stunt flier Paul Mantz. Hughes and de Havilland saw each other off and on into 1939. Soon she began seeing Stewart and then, after Stewart, John Huston, the rugged man's-man director whose 1943 aviation film *Report from the Aleutians* she deeply admired. Later she met a fighter pilot, Joseph McKeon, while he was temporarily stationed in California in 1944 as a flight instructor, and she saw him again when he came back to California, scarred and limping, following a midair collision over Germany and a stint in a Nazi prison camp. She liked men who flew airplanes.

There was a family reason for this. Her relative was Geoffrey de Havilland, the famous British aircraft manufacturer whose career in aviation had begun in 1908 and who would in 1941 design one of the most famous aircraft of the Second World War, the de Havilland Mosquito, an all-wooden airplane capable of the then-exceptional speed of 400 miles per hour. Geoffrey's sons John de Havilland and Geoffrey Raoul de Havilland were both pilots in the Royal Air Force, and Geoffrey Raoul visited Hollywood in 1943. She was not herself from Britain—she was born to British parents in Tokyo in 1916 (her father was an expert on patent law in Japan)—but although her family moved to California when she was two, de Havilland knew of her family's aviation fame.

No wonder so many of her films feature airplanes. Before she met Stewart she had starred in *Wings of the Navy* (1939), a military-preparedness adventure in production, coincidentally, as Hughes went on his around-the-world flight. In 1943 came *Government Girl*, with her part as secretary to a man bent on building as many bombers as possible.

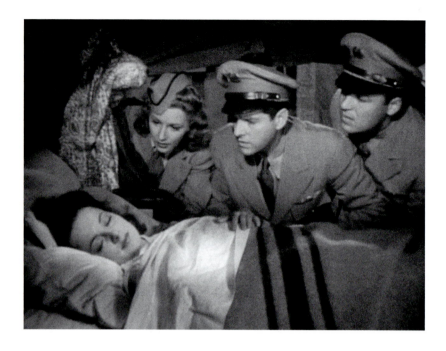

12

Princess Maria
(de Havilland)
and stewardess
(Julie Bishop),
Eddie O'Rourke
(Robert Cummings),
and Dave Campbell
(Jack Carson) in
Princess O'Rourke
(1943).

Also in 1943 she starred in *Princess O'Rourke* as a foreign princess with whom an American pilot falls in love. And in 1946, in *To Each His Own*, directed by Leisen, she plays a small-town girl seduced by a dashing World War One aviator. Aptly, a bystander looks up at the skies early in the film and proclaims that the aviator's plane is a "DH," a de Havilland. Nowadays, watching a tiny de Havilland Tiger Moth (vintage 1932) take off from an English airfield—one flies at Duxford—is to see the light bumping trundling bouncy era of aviation that marked the years when de Havilland's career started, and that her affect as an actress resembles.

In her films de Havilland's chaste sexuality is a figure for the innocent delight of flying. In *Princess O'Rourke* her for-

eign princess is unable to sleep on a transcontinental DC-3 flight from New York to San Francisco, and the stewardess, copilot, and pilot each give her sleeping pills without the knowledge of the others. When the plane lands, having been forced back to New York, they find her passed out in her berth (fig. 12). Curtained, hibernating within her enclosure, de Havilland's princess is a pure maiden of the air, snug in her heavenly bed, and the perfect match for all-American pilot Eddie O'Rourke, played by good guy Robert Cummings (center).

To Each His Own features another chaste bedroom of the skies, another innocent seduction that takes place in the air (fig. 13). The World War One aviator (John Lund)

13

Jody Norris

(de Havilland) and

Captain Bart Cosgrove

(John Lund) in

To Each His Own

(1946). Photofest.

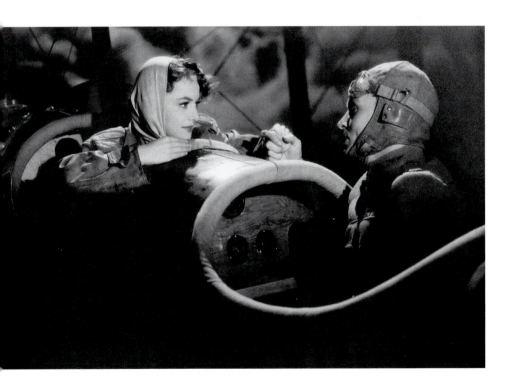

takes de Havilland's small-town girl Jody Norris up in his airplane, cuts off the engine, and tells her they are out of gas, saying dashingly he will try to make the best of it, only to discover that she is guilelessly unafraid and trusting, alive to the floating pleasures of the engine-less silence. A few scenes later we learn that Jody will have a baby, and we understand—in the absence of a bedroom scene—that it was this moonlit moment aloft, there in the gently rocking airplane, the man and woman in their separate seats, that she became pregnant. The aviator, as a commentator noted at the time, is a "supernatural being [who] descends briefly to beget the son and then disappears, so that the mother remains virtually a virgin." Hers is an immaculate conception, inseminated by the wind.

What do these flights have to do with the photograph of the picnic? Out on the hills, time for Stewart and de Havilland might have felt as free as it did when they flew around in Stewart's airplane. Years later Stewart described flying: "There's no other place I feel as relaxed and at the same time exhilarated. You're like a bird up there. It's almost as if you're not a part of society any more. All you can think about is what you're doing, and you have a complete escape from all your worldly problems." Flying, for de Havilland, was a way of living in the present. Her adventures with Stewart were part of what she approvingly called her "spur-of-the-moment life." She went with him and Swope to watch the actor fly his model airplane on the same occasion that Swope photographed Stewart contemplating the plane alone (fig. 14). The land was cracked and dry, the occasion a little odd—we can sense her tolerant bemusement at her boyfriend's hobby—but the experience

14

John Swope, *James Stewart, Olivia de Havilland, and Model Airplane*, 1940. Copyright John Swope Trust.

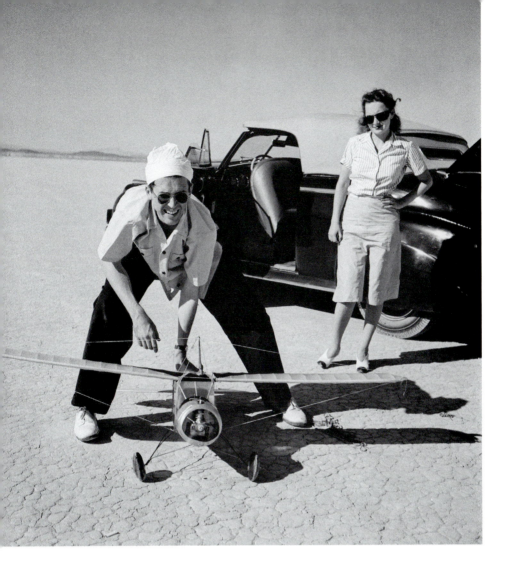

would have been as sensuous and immediate as the slice of watermelon Swope shows de Havilland biting into in four adjoining exposures.

The sensation was still more pleasurable when Stewart took de Havilland up in his real airplane, flying her up and down southern California and out over the ocean. At first "I wouldn't have flown to San Diego with Jimmy for lun-

cheon," she told the fan magazine writer Gladys Hall in 1940, but now the two of them "fly down often. . . . I love it when things like this happen." As she told Hall, "You can say that I have fallen in love—with life. With my own life, with my new life. *All* of it."

The interludes photographed by Swope take place on the ground, with or without model airplanes, on verdant hills or blank sands. But they all show the removal from society and worldly problems Stewart noted as the hallmark of flying, and they show de Havilland's way of being present in the world. The picnic was among "the new things . . . the gay, exciting things, the things that, taken all together, make life warm and crowded and rich and brightly colored" that she told Hall about in 1940. Flying was a pleasure for this actress in 1940—the sensation that made other wondrous experiences of the Now (lying on the grass, listening to music, next to a person you are in love with) feel like a form of levitation. On the picnic Stewart and de Havilland were alone and free, there in the pure cloud of their attraction. The times could not change—not for airplanes or movies. On top of their world, Stewart and de Havilland could be forgiven for believing their time as stars would never end. In the golden age of Hollywood film, the mortality of the industry could no less be imagined than the obsolescence of the propeller-driven airplanes so popular among the actors and actresses seeking their thrills. The many small "nows" that comprised those wondrous moments of being above it all were the stuff of the great Now of a business that could not think its own death. The whirring of the propeller blades must have sounded like imperishable modernity

itself, no less than the revving of the projectors or the spooling of film in its reels.

Film and prop-driven airplanes went together. "The technologies of aviation and cinema developed step by step along parallel lines," notes Robert Wohl in his book *The Spectacle of Flight*. Michael Paris puts it likewise in *From the Wright Brothers to "Top Gun"*: "The 'golden age' of aviation from the beginning of the twentieth century to the 1950s, coincides almost exactly with the 'golden age' of cinema." Paris notes that the Wright Brothers flew at Kitty Hawk in the same month, December 1903, as the New York premiere of "the first real feature film," Edwin S. Porter's *Life of an American Fireman*. By the 1920s Los Angeles had become an aviation center, paralleling Hollywood's rise as film capital of the United States. Movies such as William Wellman's *Wings* (1927), Howard Hawks's *The Dawn Patrol* (1930), and Hughes's *Hell's Angels* (1930), were made by aviators (Wellman and Hawks having learned to fly during World War One). During World War Two, film and flight went together better than ever: the rolling views from the Perspex nose cone of a B-25 in *Thirty Seconds over Tokyo* (1944) made the audience feel seated in the twin-engine bomber. In *Wing and a Prayer* (1944) real-life movie star William Eythe plays hotshot pilot Hallam Scott, a movie star who carries his Oscar with him on missions over the Pacific. But then, with the advent of jets in the later 1940s, there came the beginning of the end to this era, both of aviation and of film—a fate that Stewart and de Havilland on the hillside could not foresee.

Back in 1940, propeller-driven airplanes and the Golden Age of cinema might have seemed as if they would never

47

be thought of as slow-moving junk. The jet age could not be imagined at the moment of the slow-floating beauty world of the photograph. The historicizing of propeller flight, the turning of life to epochs and eras, commemorative cups and regretful reminiscences, are all part of what happens when a present moment slides and shifts to the next one, made obsolete in the change—a process that the man and the woman on the hill do not yet know. On September 27, 1946, Geoffrey Raoul de Havilland was killed when the experimental jet he was flying, a tailless DH 108, blew apart over the Thames Estuary as he tried to match or exceed the speeds of more than 616 miles per hour that he had already attained in the plane. Many years later de Havilland would say that her two most cherished possessions were her Oscar for *To Each His Own* and Geoffrey's christening cup, given to her by his mother following his death. But the interlocked fossils of chalice and statuette, aglitter in shiny semblance of perpetuity, mark a disenchanted historical time as surely as the stenciled incision of their legends, a far cry from the flutter of airy enchantment that knows or seeks no commemoration because its present never ends.

That is the timeless time of Swope's photograph. Back in 1940, a future of petrified mementoes would have been unimaginable. From a high point of their careers, Stewart and de Havilland surveyed the aerial dimensions of the industry's apparently boundless and immortal kingdom. This was not a fault or a failing, a case of insufficient awareness. It was instead wrapped up in the experience of the Now, the taking-in of life that de Havilland ecstatically celebrated. Things would always be this way perhaps be-

cause the moment, having achieved such a calm, would thread through itself, eye-of-the-needle style, or like a funnel gathering an immense flow of liquid, a magical sense of the imperturbability of the universe itself. Despite all evidence, despite what one knew to be the case in 1940, it might simply have been impossible just then and there for Stewart and de Havilland to think of the world or themselves changing in any way.

How different it would later become for both of them when, from the other side of the divide, Stewart and de Havilland would try to recover that time without time. They did so in distinct ways, however. For Stewart, it would be a matter of a heroic, manly quest to reach back into the past. For de Havilland, no matter how many years went by, she would be able find her magical moments of presence, of the Now, without much effort at all.

Consider Stewart first. In Robert Aldrich's 1965 film *The Flight of the Phoenix*, he plays Captain Frank Towns, an aging aviator flying a group of oil company employees across the North African desert in a beat-up old prop-plane. When a sandstorm brings the plane down, the thirteen survivors are stranded with little chance to escape alive. They can start out across the desert, or they can wait by the plane and hope to be rescued. Choosing the latter course, they bide their time day after day, but with food, water, and morale diminishing and no rescue plane in sight, they agree to a plan they first dismissed as crazy. Following the idea of one of the survivors, the German engineer Heinrich Dorfmann (Hardy Krüger), they salvage parts of their wrecked twin-engine plane to build a new,

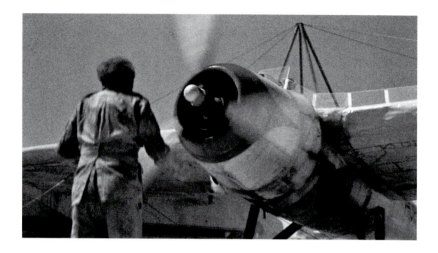

The propeller starts
in *The Flight of the
Phoenix* (1965).

smaller single-engine plane, drag it to a level stretch of sand, climb aboard the wings and, with Captain Towns at the controls, fly to their salvation. In the film's most iconic scene, Towns expends five of the plane's seven remaining starter cartridges without starting the engine before finally succeeding on the sixth try, to the ecstatic relief of the men who know then that they will survive (fig. 15).

The movie is a Hollywood parable: the old-school actor and his airplane are in a hopeless situation, both getting on in years. His dilapidated craft wrecked, his credibility called into question (some of the passengers blame him for the predicament), Captain Frank Towns seems to age before our eyes. Stuck for days in the desert, subject to the brutal light, wind, and sand, Stewart's character becomes older than the fifty-seven-year-old actor, in some hyperbolic portrayal of filmic superannuation. Like the 1940s Hollywood star Tom Conway, who was discovered in 1965 living a hand-to-mouth existence at a Venice Beach motel,

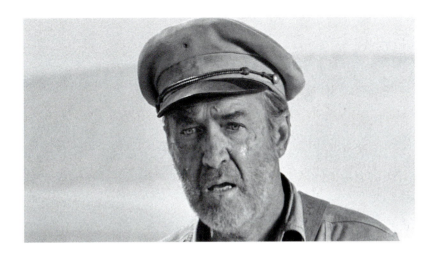

Frank Towns (Stewart)
in *The Flight of the
Phoenix* (1965).

Stewart in these desert moments calls to mind a weather-beaten traveler, down on his luck, staggering through the sands of all he has lost (fig. 16). "Flying used to be fun," Towns says early in the movie, and though he may be "one of the greatest pilots left in this push-button world," as one of the other characters says, the old man has fallen on hard times.

But then the rebirth happens, the plane is resurrected. Cannibalized from the obsolescent remains of the old model, the Phoenix emerges from extinction, with Stewart's character heroic and alone at the controls, a lifesaver. He could not do it without the brilliant design of the cool German engineer Dorfmann, who conceives the vehicle for Towns to fly, but Stewart's character triumphs in this stripped-down prop-driven plane created in an atmosphere of desperation and ingenuity. By contrast, the prehistoric airplanes in other films from those years are not old friends. In Alfred Hitchcock's *North by Northwest* (1959), the fa-

mous crop duster vengefully bears down on Cary Grant as though to kill the famous star for deigning to occupy the infinitely flat no-man's-land of a movie world that had lost touch with the barnstorming days of old Hollywood. In Michelangelo Antonioni's *Blow-Up* (1966), Thomas (David Hemmings) emerges incongruously from an antique store with a ca. 1910 single-blade propeller, an apparent non sequitur that might refer to a seemingly discarded cinematic past, the one-time whirring marvel now consigned to the status of mod décor and useless bric-a-brac. But *Flight of the Phoenix* has grander ambitions for the old times. Their spirit can be heroically recovered and put to good use. At the conclusion of filming the cast and crew gave Stewart an autographed propeller blade.

How different it was for de Havilland. She faced the same battles and indignities as Stewart during the era of jets, but she did so with a sense that the glories of a moment of true presence were always near at hand. They required no valiant quest to rediscover. In 1964 she wrote to John Huston, the rugged director she had loved after Stewart back in the early 1940s, to describe how she had been instantly brought back in time upon going to see Huston's film *Freud* (1962) the previous spring. "It had already begun when I walked into the theater," she wrote Huston, "and so, still in the foyer before entering the salle itself, I heard your voice. It was an extraordinary experience, for no one had told me that you had done the soundtrack, and, of course, with the first word I knew it was you speaking. It brought back, with a rush, the year of 1942 and the Aleutians, and the film you made there, that beautiful film"—Huston's aviation documentary, *Report from the Aleutians*, released in 1943.

Time condenses in the extraordinary experience, the quickened recollection of a bright image. Huston's film of American bombers flying over the cold blue ocean comes instantly to de Havilland's mind. The airplanes affix to vision, not like butterflies in an album but on the air itself. Sluicing through the Alaskan fog, the beautiful picture appears, yes, thanks to an authoritative man's commanding voice. And it takes place in a theater of the mind—with *Freud* playing, the movie having already begun, and Olivia still in the lobby, late for an appointment, as people are wont to be in their dreams. But who cares what the impetus is if time returns, and does so "with a rush." As de Havilland said in 1964 about seeing herself on television, "I don't mind my old pictures being shown. It means they are works with long life. . . . That's very thrilling. Generations coming up can see that work develop and that makes me current. I can afford to go away and come back."

It did not matter that de Havilland's later-life aviation films were disasters—she outlived the deaths she died in them. She was featured as a passenger on an ill-fated jetliner owned by Stewart's character in *Airport '77*, not a critical success. The next year she appeared in a flying film of another kind, *The Swarm* (1978), in which she was attacked by hordes of Brazilian killer bees. In each case de Havilland was intrepid. She allowed herself to be submerged underwater in *Airport '77*, and in *The Swarm* she lay "on the floor of a simulated train coach, her face and body covered by thousands of live bees, her skin prickling under what sounded like a buzzing field of electrical energy," keeping still even when one of the bees began to enter her nose. Yet the movie, like the bees, could not

harm her. As impervious to death as adolescent Hermia was in 1935, she could not die. More than her bravery kept her safe. What is it?

Maybe it is her seeming immortality. Melanie is the only one of the main characters in *Gone with the Wind* to die, but de Havilland has outlived all the other stars of that film now by more than four decades (Leslie Howard died in 1943, Clark Gable in 1960, and Vivien Leigh in 1967). She has also survived all the major players and virtually *everyone* associated with the film. She has done so, moreover, with her present tense intact. At a Hollywood tribute two weeks before her ninetieth birthday in 2006, de Havilland "gave new meaning to the word 'spry,'" according to a reporter. "She basked in three standing ovations" at the tribute, "resplendent in a bright white suit with knee-length skirt, scoop-neck collar and matching pumps." Her gift for flirtation intact, she looked a seventy-year-old male reporter in the eye that year and declared, "I'm old enough to be your mother." In 1998 she attended the unveiling of a statue of Geoffrey de Havilland, Sr., at a British airfield and waved to the skies as a group of antiquated de Havilland planes flew overhead, as if not a minute had passed since their glory days. In 2005, asked the question by *Vanity Fair* magazine, "How would you like to die?" she responded:

> I would prefer to live forever in perfect health, but if
> I must at some time leave this life I would like to do
> so ensconced on a chaise longue, perfumed, wearing
> a velvet robe and pearl earrings, with a flute of champagne beside me and having just discovered the last
> problem in a British cryptic crossword.

Swope's photograph, too, is about living forever. Moments of presence defeat the passage of time not only in and of themselves, but also by linking to all other such moments in a person's life. No wonder it has been easy for de Havilland to bridge the years from 2005 to 1940, or any other long span of her life. But how does this timelessness relate to history, and especially to the momentous year of 1940? She knew what was happening in the world when Swope photographed her. That year, shortly after the premiere of *Gone with the Wind*, she had attended a luncheon at the White House and been "awestruck" by President Roosevelt, whose policies she supported. So how was it possible for someone so much in time to be outside of time? For an answer think of the quality of sleep, or near-sleep, in the photograph, and consider that there are different kinds of sleep, different kinds of oblivion.

One is the kind we see in the 1935 production of *A Midsummer Night's Dream*, de Havilland's film debut. In one scene Titania and her fairies nestle on the ground, preparing to slumber at the end of the enchanted evening (fig. 17). Soon they will be rounded up by the black-clad Oberon and other billowing emissaries of the night, gathered and marched away at the break of day. In viewing these disturbing and breathtaking scenes, which repeat the stage version at the Hollywood Bowl, we begin to understand why Reinhardt was in California in the first place.

He came there after disturbing events in Berlin. "After Hitler had been named Reich Chancellor early in 1933, Reinhardt had watched the Nazis disrupt and then close a production in his Deutsches Theater in which two Jews had key roles," writes the Shakespeare scholar Gary

Jay Williams. "When in March he himself had directed Calderón de la Barca's *The Great World Theatre* there, adapted by Hofmannsthal, both the Jewish dramatist and the Jewish director were the targets of Nazi anti-semitic criticism in Joseph Goebbels's newspaper, *Der Angriff.*" Reinhardt left Berlin and soon accepted the invitation to come to California, where the black-caped Oberon and his emissaries comprise "the first dark theatrical images in the performance history of the play," writes Williams, and belong "to the troubled twentieth century."

The sleep of the fairies predicts the mass graves, the fleeing naked figures huddled for slaughter, of the 1940s. Yet Hermia and Lysander, Helena and Demetrius, asleep in Reinhardt's production, are unaffected by this chaos. Although de Havilland's Hermia writhes in a nightmare at one point, it is possible to agree with Harold Bloom that the pairs of young lovers are essentially just beautiful people dithering along in the splendors of their random infatuations, and that the real energies of the play pass them by. And what was true for de Havilland in Reinhardt's production might appear to be true for her and Stewart on their drowsy picnic. Sleep is inoculated by death the better to be immortal, as when the stewardess briefly checks the princess's pulse in *Princess O'Rourke*, showing us that her sleep is all the more sleep for having looked for a moment like death; as when Hermia and Lysander play at mortality; and as when de Havilland and Stewart defy the scratching needle of the ongoing day to say that shadows are but another form of the lightness that lets them defy time. So de Havilland appears to sleep or nearly sleep through history, not wakened even by the loudest, sharpest alarms, like a

17
Titania (Anita Louise)
and fairies in
*A Midsummer Night's
Dream*. Margaret
Herrick Library.

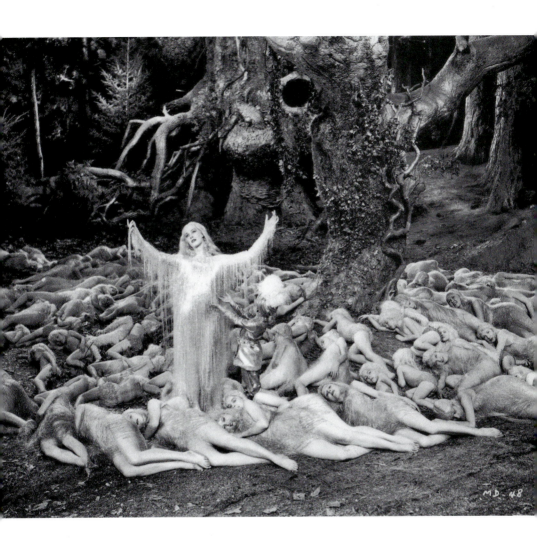

child dozing through a terrifying storm, lacking any sense of the mortal world that surrounds her. But this is in fact *not* the quality of her sleep, her magic immunity from time.

Nor is her sleep that of a land that time has passed by. Saratoga, California, where de Havilland lived from the age of two until she went to Hollywood in 1934, is the definition of a sleepy town. Going there now, I find the boardinghouse where she spent her first years and the house on La Paloma Avenue a few blocks away where she lived as an older child and teenager. Just down the street from that house, I meet with local resident Willys Peck, eighty-nine years old at the time of our conversation, who recalls when de Havilland would babysit him when he was a boy.

Peck met me at his house, which I discover to be a Land That Time Forgot, conceived along Peter Pan lines, a rambling treasure-trove with an amphitheater for open-air stage productions in the back, complete with a tree house balcony for *Romeo and Juliet* scenes, and the Saratoga Creek running in a ravine behind the stage. In the front yard I cross the tracks of a small-scale model railroad that encircles the many-gabled home, and I note magical inscriptions, all over the place, written on rocks as though by fairies and hobgoblins, friendly-freaky aphorisms of the kind that apparently flow effortlessly from these little creatures, from the tops of their gnarly heads of hair down to the last tendril curl of their pointy slippers. Inside the house Peck shows me various memorabilia, including a dress worn by the Broadway actress Dorothea Johnston in an early 1930s performance, a dress sparkling and stiff, as though dipped in plaster, hanging on a wall in a cluttered room.

Then he shows me, somewhere back in a jumble of furniture in storage, a relic not really visible—a you'll-have-to-take-my-word-for-it kind of thing—the desk de Havilland did her homework on while she babysat for Peck back around 1930. Among Peck's files we see a copy of a mimeographed yearbook of the Saratoga Grammar School, dated February 1930—a yearbook with de Havilland listed in the masthead as editor-in-chief and bearing the charming Lindbergh-era title, the *Aero Vista*. At the nearby Historical Society are photographs of Olivia as a girl playing Alice in *Alice in Wonderland* and as Puck in the local *Midsummer Night's Dream*, and others of Olivia and her sister Joan Fontaine standing in front of their house on La Paloma in historical costume, possibly connected to the bicentennial celebration in 1932 of George Washington's birth. History is something these future Hollywood actresses could affect, dressing up in the regalia of it, but remain somehow apart from. Meanwhile, the constant sound of the Saratoga Creek and the yellowed fluttery clippings of bygone events are the doubled registers of time in this forgotten zone, a Peter Pan microclimate of soaring trees and loving kindness, of ancient memory and innocence sublimely prolonged. But de Havilland left this place, and its sleep is not her sleep.

Hers instead is the sleep of the unscathed. It is the sleep of someone who made it out of the devastating twentieth century, which she saw virtually the entirety of, not because she was oblivious, and not because she was sheltered in a vine-strewn village, but because she went into the midst of things and, magically, emerged untouched. She was like a princess in a trance, protected by a spell or

charm. What we might account a curse, that the world not touch us, was for her a blessing. In some of those films from the war years, the documentaries, we see the airplanes on their bombing raids over enemy territory: some are shot down; many return home mangled by flak, in states of disrepair and junk-heap ruin. But there is always one plane that mysteriously returns without so much as a single mark. Olivia de Havilland's gift was to make it out alive, without a scratch.

When the World Smiled
Margaret Bourke-White

Margaret Bourke-White sped along on board the *Super Chief* en route from Chicago to Los Angeles. She had already taken the *20th-Century Limited* from New York to Chicago, and now she was traveling the route farther west, sometimes at better than mile-a-minute speed, through Missouri, Kansas, the southeast corner of Colorado, New Mexico, Arizona, and on into Los Angeles. The *Super Chief* was called the train of the stars, noted for making a special stop in Pasadena to let off Hollywood worthies, and Bourke-White was herself a celebrity. One of the four photographers hired to staff *Life* magazine when it began in 1936, she was one of the most famous women in America. She made daring pictures, and she had a glamorous public persona to match. Now, on April 24, 1943, Bourke-White was going to Hollywood at the behest of legendary producer Samuel Goldwyn to take promotional photographs on the set of *The North Star*, his epic film then in production.

She carried an excessive amount of camera equipment. In her baggage were two Linhofs, a Soho, a Graflex, a Rolliflex, and a Speed Graphic. For the Linhof cameras alone, she had thirteen lenses. As in the story of the man going to St. Ives, the baggage proliferated. Each lens came with a magnet coil, tripper, and battery case for synchronized flash. Both Linhofs came with range-finders, blade-arrester shutter devices for quick focusing, and a ball-bearing mechanism for infinity stops. Each Linhof also had a "Quick-Set Hi-Boy tripod with tilt tops," according to a period account, for when Bourke-White was not using them hand-held with the range-finder. The Soho came with three interchangeable lenses, the Graflex and Rolliflex with numerous filters that she could use interchangeably on the Linhofs, and the Rolliflex was "synchronized with [a] Heiland-Sol magnet coil for using flash bulbs." Then there were the bulbs themselves: small peanut-types for "compactness in transportation," larger ones for use when she wished to illuminate a broader area, and blue bulbs "to fill in shadows." She had lost almost all her camera equipment four months earlier, when a U-boat torpedo sunk her transport ship off the coast of North Africa on December 22, 1942. But her Los Angeles cargo was not a compensation for that loss. Bourke-White had six cameras on board ship and there were six on the train to L.A as well. It was simply her way of working.

In North Africa, after her ocean rescue, Bourke-White had spent time with American B-17 squadrons, going on a bombing mission over Tunis that resulted in one of the most famous *Life* photographs of the war, featured in the March 1, 1943 issue. She poses in a high-altitude flying suit, holding a Fairchild K-20 aerial camera, standing in front

18

Margaret
Bourke-White
in High-Altitude
Flying Suit, 1943.
Time & Life Pictures,
Getty Images.

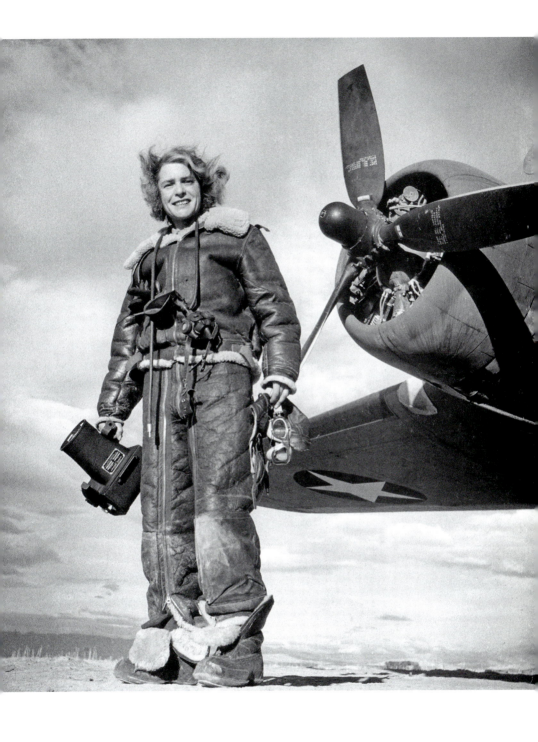

of one of the four Pratt and Whitney 1200-horsepower engines of a B-17 (fig. 18). Then thirty-eight years old, Bourke-White stands tall with her fearless smile, the first woman given government permission to go on a combat mission. As she traveled to Los Angeles, she was never more renowned.

Bourke-White's moment was always the Now. On her North African combat mission, which took place on January 22, 1943, the plane crossed into enemy territory and the bombardier went from his post in the nose of the plane down into the bomb bay to remove the safety pins from the bombs. She knew why he had left his post and steadily followed him with her camera, her movements slow and careful in the cramped quarters and cumbersome flying suit. Down in the bomb bay, once her eyes were accustomed to the darkness, she "could just make out the bomb racks stacked neatly like bookshelves in a public library," as she put it. As the bombardier pulled the pins from the bombs, he removed the yellow tags attached to the pins and put them in his cap and his mouth, saving them for souvenirs. As he did so, Bourke-White, who had nestled among the bombs with her camera unbeknownst to him, took a flash photograph, with a resultant shock. The bombardier thought the bombs were blowing up—"Jesus Christ, they're exploding in my hands!" he screamed into the plane's interphone system—until Bourke-White spoke into her headset to apologize and he realized what had happened.

Here were two senses of history. The bombardier was thinking down the line, removing the tags as mementos of the mission for himself and for the rest of the crew. Chances are he thought the crew would survive just fine that day—

the mission to Tunis and nearby Bizerte was regarded as a "milk run," a low-risk operation—and the bombardier, when the plane returned, would write "Tunis" and the day's date on the tags and put them away with others from previous missions for safekeeping. If he survived the war, he would then have his own complete archive of the missions he had been on—an archive that would outlive him. Even as the plane flew, he was curating the dry and dusty papers that no one except the occasional historian or curious relative would ever consult. The bombardier's preservation of the past was in keeping with the "bookshelves" of the bomb racks, the bibliography of the bomber.

But in the midst of this antiquarian exercise, Bourke-White had another sense of history. Hers was all about the instant, the flash, the explosion. From her kinship with the bombs, she too would aim to make her mark. In pure shock value, the explosive instant would overcome the dustier sense of a history kept safe for a more prolonged but forgotten perpetuity: the attics of precious-worthless stuff, the accumulated souvenirs of some other person's life a lifetime ago. If the photographs she took on that mission have now become archival, moldering in quasi-decrepitude in the big bound volumes of *Life* that bend and sag and flake apart in library stacks, their up-to-the-minute journalism now subject to forces of time that even the canned meats advertised in their pages cannot withstand, these indignities of time need not take our attention from Bourke-White's belief in the Now.

That belief was extra strong at great heights. In the winter of 1929–30 Bourke-White was hired to make photographs of the Chrysler Building, then under construction and soon (briefly) to attain the rank of tallest building in

the world, at some 1,042 feet. Bourke-White, then twenty-five years old, had come to the attention of publishing tycoon Henry Luce because of her photographs of the Chrysler plant in Detroit and the steel industry and sky-scrapers of Cleveland, and now Luce had hired her to make pictures of the final construction stages of the vertiginous new building in Manhattan, then nearing completion. She was so taken by the gargoyles on the sixty-first floor that she decided to move to New York and set up her studio in one of the spaces on that floor, and from late 1930 to 1934 that is where she worked. A photograph by her assistant Oscar Graubner shows her inching out on one of the gargoyles, eight hundred feet above the street (fig. 19).

Being up so high was an exhilaration of the moment. At those heights, it was easy to get carried away—Bourke-White's goal. As carefully as she could—her images were made to precise standards—she wanted to show the moment when the world escaped her control, when it flew away from her, and she from it. This fantasy condition of flight was partly what her advertising employers wanted. "This car was not an automobile in the ordinary sense; it was a winged chariot which floated smoothly off into space," Bourke-White wrote in 1936 about her pictures for one such commercial photo-shoot. But it was also her own view of things: her wish to show the world in wild and un-trammeled arcs, free from the encumbrance of calculation, free even from the finicky devising of the image itself. It was this wheeling lightness of the moment that she sought, the falcon beyond the range of her falconer.

On the Chrysler Building, this was the case. Making pic-tures from the gargoyle and other vantages, she wanted to

19

Oscar Graubner,
*Margaret
Bourke-White atop
a Chrysler Building
Gargoyle*, ca. 1931–34.
Time & Life Pictures,
Getty Images.

be in thrall to forces greater than herself, overcome by sharp plunges and dizzying angles. Staring down a thousand feet of elevator shaft, tilting up to show the spindly tower, she sought the flinging-out and fleeing of space—its way of escaping from her—as though in the absence of actual angels' wings these views were a sufficient enough sign of all that was not of this world. The very shimmer of her surfaces is instinct with this delirium, as if rubbed with a mirage of height. For this master of artifice, who could bend her shadows like rubber around a pipe, or pour you a vial of light as thick as concrete, silver metal comes lacquered in sky and clouds. And in all this the Now would be the soldering force, snapping into place the moment when the world and the photographer fled each other with reciprocal velocity, the crossing of two ecstasies, passing one another by in a blur that Bourke-White froze into a sex appeal of steel.

Up high, animals were a sign of the wildness of the Now. On the balcony of her sixty-first-floor studio, where she could look daily upon the gargoyles she so admired, Bourke-White kept exotic pets, a menagerie that included two small alligators and some turtles. They were reminders of her days studying reptiles as a schoolgirl. "At feeding time," she wrote many years later, "I tossed the alligators big slabs of raw beef which they playfully tore from each other." Soon the alligators "grew very fast and ate a great deal, even bolting down several of my turtles, shell and all. I thought they would find this meal quite indigestible, but they calmly slept it off." The chaos was perfect for the elevation, and Fay Wray could not have put it better: "It astonished me to find the law of the jungle operating in a penthouse at the top of a skyscraper."

Bourke-White's alligators were the heraldry of her manic creativity, the crest of her genius. They were her "circus animals," as in W. B. Yeats's phrase—signs of her inspired vision. Yeats's circus animals were leaving him in 1939, the year he wrote the poem and the year of his death (the poem is called "The Circus Animals' Desertion"), but Bourke-White's creatures had just arrived in the early 1930s and would last her for many years, death of the real ones or not, as the animal spirits of her vertiginous pictures. Crawling out on the gargoyle just beyond the creatures' balcony home, she was wild.

And the ghost of that wildness remained long after the Now had passed. In 1965, more than three decades after Bourke-White had vacated the Chrysler Building studio, an acquaintance and former Chrysler Building worker named Marjorie Follmer wrote to her to say that she had recently visited the exact location on the sixty-first floor that had been the photographer's studio. Finding that Bourke-White's rooms were occupied by a management consulting firm called Henry Schindall Associates, Follmer spoke with Mr. Schindall himself, who showed her around and noted that in the summertime he liked to walk out on "the little balcony, which he called a 'terrace'"—the place where the alligators had lived. Mr. Schindall then showed Follmer his private office, decorated with "framed portrait-photographs of great men—Somerset Maugham, Ernest Hemingway, Bertrand Russell, Schweitzer, Einstein and others—by Yousuf Karsh." The great men immortalized by Karsh had taken up sedate residence where Bourke-White achieved her wild fame. But Follmer notes that an untamed element remained. "The drafts still howl in the elevators of

the Chrysler Building. I'd forgotten about that howling on the upper floors. And, of course, the views are still stupendous." The howl of the views, like some banshee of the spot, retained its power even after all the years.

Back in the early 1930s, posing for Graubner's photograph, Bourke-White wanted to show her own abduction, to capture what captivated her. And so the Olympian bird takes her away like Jupiter did Ganymede. By the 1940s, however, her heights were arguably not so inspired. She had been the barnstormer of her own ecstasy, but on the B-17 her dizzy exposure to the elements had become the stuff of flight suits, radio intercoms, and industrial teamwork in a factory of the air. The photographs she took, such as one of the burning fuel dump at the Tunis Airport, emphasized the industrial efficiency of American bombing (fig. 20). The black smoke appears like a plumed pin on the map of the world, a sign for *Life* readers of the efficiency of American war plans. The editors chose to crop the photograph, cutting off the B-17 to the left and putting the plume at the left edge, giving the bomb strike a more vivid presence and emphasizing the strategic pay-off of the mission. The preceding and following pages of the magazine feature overhead maps of North Africa, helping readers understand Bourke-White's photograph as itself a diagram. Reassuringly, war and its representation are the same. Making propaganda required that nothing exceed her grasp.

Yet here too Bourke-White was carried away, higher and farther than she had ever been. Now she was flying at the height of twenty-two Chrysler Buildings. The altitude far surpassed the most extreme of her previous elevations, such as the views she had made for the International Paper Cor-

20

Margaret

Bourke-White, *B-17s*

on Bombing Mission

over Tunis, 1943.

Time & Life Pictures,

Getty Images.

poration in the Gatineau River region of northern Quebec in 1937, when from several thousand feet she had made a flotilla of lumber look like a giant lily pad. If the patterned plume at Tunis recalled the neatness of such peacetime designs, the far greater elevation made the whole experience much wilder. At four miles up Bourke-White's frozen breath clogged her oxygen tube, requiring her to pinch the line to break the ice away, and the slipstream around a turret she sometimes looked out of traveled at a "decapitating"

two hundred miles an hour. The whole situation was crazy. Was it really a good idea to go up on a bombing mission, even a milk run, if you did not have to? The flash in the bomb bay might actually have caused a disaster instead of only simulating one, and her plane had to face German flak and a few Messerschmitt Me 109 fighters bearing down on the formation. But the wildest feeling of all may have been being up so high. In a photograph where the black smoke is the money shot, flying at more than 20,000 feet is the real thrill of the moment.

Now, some seven weeks after the publication of that bombing article in *Life*, Bourke-White exited the *Super Chief* and stepped into Los Angeles. She was an instant presence. The moment was wherever she was. Arriving in town on the evening of April 25th, she held court with reporters at the Beverly Hills Hotel, her bright face appearing in the *Los Angeles Times* the next day, "bubbling over" with news, according to one of the reporters. On the evening of April 26th, nothing daunted by her cross-country trip, she gave a ticket-only lecture on her North African experiences at the Los Angeles Town Hall.

On the 27th she started work on the set of *The North Star*, where she was no less a celebrity. "Grips, juicers, gaffers, makeup artists, cameramen, directors, and assistants asked her for autographs and watched for an opportunity to exchange a few words of conversation," according to an account written later that year. Her fame was equal to that of other nationally known talents brought in to make the film—Aaron Copland, for example, who wrote the music, and Ira Gershwin, who wrote the lyrics. Perhaps thinking to capitalize on

her "Bourke-White Goes Bombing" photograph, which had become a pin-up among servicemen, Goldwyn's publicity department even photographed her in a bathing suit at the Town House pool. Wherever she went, Bourke-White made her own time, specifically the aura of the present.

This immediacy, however, took place against another temporality—a backdrop of prolonged, even terrifyingly endless time. Consider three such infinities unfolding just then, in those days of Bourke-White's stay in Los Angeles. The first: on the afternoon of April 4, 1943, a B-24 Liberator named *Lady Be Good* took off from its base at Soluch, Libya, thirty miles south of Benghazi, on a bombing mission to Naples. Aboard was a nine-man crew headed by pilot William Hatton, the leftmost figure in a photograph of the crew taken around that time (fig. 21). The *Lady Be Good* was part of the same Allied air command Bourke-White had covered from the B-17 base in Biskra, Algeria, and the crewmembers, who had recently arrived in Africa from the United States, probably knew her *Life* article. Some time in late March or early April, the crew gave their bomber its name, a reference to the 1941 film *Lady Be Good*, starring Robert Young, Ann Sothern, and Eleanor Powell, that included an eponymous hit tune, written in the 1920s by George and Ira Gershwin. Now, on its first mission, the *Lady Be Good* took off on the seven-hundred-mile flight to Naples.

The mission had problems from the first. An afternoon sandstorm at takeoff caused mechanical problems that led many planes to abort their missions, some returning to base long before reaching Naples, others making it much farther before turning back. Even so, the attack, held in conjunction

with B-17s based in Algeria, was deemed a success, and at nightfall all but two of the B-24s from Soluch had returned or been accounted for. The next morning, one of these two reported in from Malta, where it had landed after running low on fuel. That left only one, the *Lady Be Good*, missing.

No word of it ever reached the base. What happened was this. Having become separated from the other planes, the novice crew of the *Lady Be Good* flew back over the Mediterranean alone at night and missed what even veteran airmen had to be very careful to look for: "The slight, light line of breakers on the beach." This was the one indication, if you were not directly on course, that showed you where the ocean ended and the desert began. Otherwise, the desert at night looked just like the ocean, and with no lights anywhere, you might fly, as the *Lady Be Good* did that night, on and on, past friends, past foes, out over the vast Libyan sands.

The plane was not found until 1958. Employees of British Petroleum, flying over the desert in search of oil sites, spotted some mysterious wreckage. Subsequent flights at lower altitudes indicated that the plane was an old World War Two bomber of American make, a plane that "even from the air . . . seemed to have a haunted quality." In February 1959 an expedition was launched to reach it. Headed by oil-company geologist Don Sheridan, the group located the B-24 and found it "a journey back in time." There were no crewmen anywhere—it quickly became clear that they had bailed out—but the plane had landed virtually intact by itself, leaving everything in a state of near-perfect preservation. The searchers found nearly full belts of .50 caliber ammunition intact at each machine gun, as well as "articles

21

The crew of the
Lady Be Good, 1943.
Photo courtesy of
the National Museum
of the U.S. Air Force.

of clothing and other equipment . . . scattered throughout the plane, each bearing the name of its owner." There was a Colt .45 revolver, William Hatton's, on the pilot's seat. As historian Mario Martinez puts it in his book about the plane: "The mummified remains of birds which over the years had sought refuge from the desert sun lay scattered along the bomber's crushed floor, alongside decayed cigarette and sweet wrappers dropped there long ago." Near the cockpit was "a thermos jug . . . containing what smelled like coffee," and in a hatch on top of the fuselage, incredibly, containers holding four pints of water that had not evaporated in almost sixteen years.

Nearly a year later, oil company employees drilling a water well found five skeletons about seventy-eight miles

from the spot of the bomber wreckage. The remains were "closely grouped in an area littered with canteens, flashlights, pieces of parachute fabric, flight jackets, shoes and other bits of equipment and personal belongings," including Hatton's wedding ring, inscribed "Love to W.J.H. from A.J. 9-3-42." The discoverers also found the diary of copilot Robert Toner, one of two diaries recovered, detailing what had happened to the crew. They had indeed lost their way and, almost out of fuel, bailed out at 2 a.m. on April 5th. In brief entries Toner described what became of them afterward. The last entry was dated April 12. A few months after this discovery, the remains of two more crewmen were found, one a hundred miles and the other a hundred and fifteen miles from the wreck, and later that year another oil crew working about sixteen miles from the crash site found the body of the bombardier, John Woravka (fourth from left in the photograph), on his back, still wearing his Mae West lifejacket, with his unopened parachute on top of him. The body of the ninth crew member, Vernon Moore, has never been found.

These men had only begun to be dead when Bourke-White arrived in Los Angeles. She, of course, knew nothing about their fates. No one did until 1960, but when the fate of the plane and the crew became a widely reported story and she heard the gruesome news, she was perhaps pierced by it more than most Americans. The fate of the *Lady Be Good* would have recalled her own days in North Africa in 1943, and the horrible deaths of the crew might have elicited a special pang of sympathy from a person then suffering, as she had been since the early 1950s, from the Parkinson's disease that had ended her career and would end her

life in 1971. But the deaths of Hatton and his crew offer a vivid backdrop for the ecstatic instants Bourke-White was busy creating in Los Angeles in April 1943. Her moments of verve and excitement vanquished the granular oblivion of infinite time. Hatton and company had suffered an especially hellish form of the perpetuity confronting all the war dead that Bourke-White's glorious Now denied. Her work was like an exorcism of the dead, a flashing shock so persuasive and exciting that it would leave no sign of the other form of time that many besides the *Lady Be Good* crew were then beginning to experience.

The dispatches from this infinite time sound like voices carving the caves they speak from. In one of bombardier Woravka's shirt pockets, the discoverers of his body found a blank notepad, or what they thought to be a blank notepad. It was long presumed to be empty, but many years later someone perusing it found a single page with three questions written on it. These were evidently addressed to a fellow crewmember on the way to Naples during a period of radio silence, when the drone of the plane's four engines prevented ordinary spoken communication. The questions—"What's he beeching [bitching] about? What's going to happen? Are we going home?"—have the aura of permanent mysteries, the riddles of a Sphinx found with his canteen still three-quarters full of water. Toner's diary, neatly written even on the last day ("No help yet, very cold nite"), delineates final words as clearly marked and preserved against time as the skeletons amid the dunes. And a letter Hatton had written to his mother the previous autumn when in Salt Lake City, as he awaited transfer to another American location for further training, not only

survives Hatton but survives "Bourke-White Goes Bombing" for having caught the spirit of an oblivion her Now could never see. "There are about four places they can send me. Arizona, Idaho, and Spokane or Tacoma, Washington. I am sitting here waiting to see which one it is. I hope it isn't Arizona because I am tired of sand."

A second infinity: on April 16, 1943, the Hollywood director William Wyler went up in a B-17 on a bombing raid destined for the U-boat pens at Lorient and Brest in occupied France. Wyler was in England shooting footage for the color documentary *The Memphis Belle*, which would be released to much acclaim a year later. On that day in April 1943, Wyler's B-17 had to turn back because of a fuel shortage prior to reaching the target, but when all the bombers were back to base Wyler filmed the flak damage some of them had suffered, footage that appears in the documentary, and learned that his sound man, aboard a B-24 on the same raid, had been killed when that plane was shot down. Then, a month later, on May 17, with Bourke-White either still in Los Angeles or having just left (she was there as late as May 11), Wyler went up in *The Memphis Belle*, again to Lorient, and then a few days later on another raid to Kiel. On these missions he took a great deal of combat footage that appears in the film, including about ten seconds showing a B-17 slowly twirling through the air, out of control (fig. 22).

The plane's fall, in a manner of speaking, goes on today. It occurs in slow time, not because Wyler slowed his film but because the gentle spiral of the plane, though rapid, appears as a gradual descent, the plane having only just begun to generate its downward momentum. The lack of fire or structural damage, moreover, gives the terrible plunge a

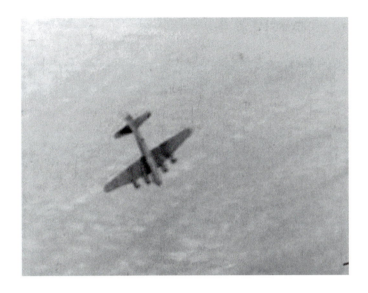

kind of calm. What we see lasts only a few seconds, but it seems to go on forever. We watch as first one crewmember jumps from the plane, and then another, their parachutes opening, as the plane with the other eight crew members still on board falls from twenty thousand feet. Meanwhile the gun battle going on against German Focke-Wulf Fw 190 fighters takes place at an extraordinary rate of speed. The German planes, appearing as specks in the sky, gone before you know it as they make their passes, fire 2,300 rounds per minute, we are told by the narrator, and the Americans shoot back at their own good clip. But this one B-17 falls, pirouetting downward, obeying other laws, the emissary of some different state of existence, silhouetted against the check patterns of the countryside far below: a timeless fall, still falling to this day (we never see it crash, we never see it even approach the ground), suspended forever in its lost moment.

22

A falling B-17 in *The Memphis Belle* (1944).

Meanwhile, the men aboard Wyler's plane, speaking over the intercom, give a play-by-play of their concern. Commenting on the doomed plane, urging the remaining crew to bail out, they sound suspiciously like radio announcers at a sporting event. It is not a surprise to learn that the intercom chatter was dubbed in later, Wyler's technical capabilities not having allowed for the actual real-time recording of the voices aboard the aircraft. Historical narration, unpersuasively calm, aspires to simultaneity with what it describes, but it is a commentary after the fact. It smoothes the traumatic moment that twirls to the beauty of its own rules, that invents the conditions of its private world, the glinting sun and farmers' fields, unknowable and everlasting. Bourke-White was no friend of historical postscripts, but she was equally a stranger to the moment that lasts forever.

23

Olga (Ann Carter),

Marina (Anne Baxter),

and Sophia

(Ann Harding)

in *The North Star*

(1943).

A third infinity comes from the set of *The North Star*. At the start of the film, which concerns the fate of a Russian village on June 22, 1941, the day the Nazis commenced Operation Barbarossa, the surprise invasion of the Soviet Union, we meet two friendly and likable ordinary Russian families going about their daily routine, the Pavlovas and the Simonovs. In one of these early scenes the female members of the Pavlova family, mother Sophia (Ann Harding), older daughter Marina (Anne Baxter), and younger daughter Olga (Ann Carter), do each other's hair (fig. 23). We are meant to see three ages of humanity, but we also see the inability of the film to think historically, for in this depiction of different ages we see the fundamental and uncanny *sameness* of the three characters, a sameness emphasized by the coincidence that all three actresses are named Ann or Anne. This sameness is the mark of Hollywood standard-

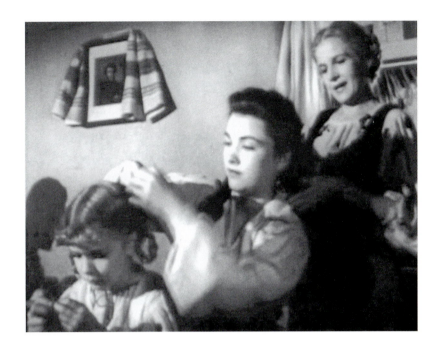

ization, what James Agee in 1944 called Hollywood's way of showing "how a generalized face can suggest a generalized emotion in a generalized light."

It is striking, then, to think of Ann Carter, then nearly seven years old, as a historical person. When I talked to her in the summer of 2011, she had just celebrated her seventy-fifth birthday, and she recalled a number of things about *The North Star* set. Margaret Bourke-White was not one of them—Carter did not remember that the famous photographer had been there—but she did recollect that during the filming a lamb had been born to one of the many sheep brought in to be the farm animals in the Russian village. Carter recalled that she had been photographed holding the lamb a few hours after it had been born, and that the pho-

tograph had appeared on the cover of the *Los Angeles Times* Sunday magazine at some point during the making of the film. This image (fig. 24), which did indeed appear on May 2, 1943, is vivid now not so much for its sentimentality as for the way it marks the *exactness* of historical memory, the way an accurate recollection erases the distance between then and now, acquiring a rightness unto itself by its truthfulness. Even a cute and cuddly picture such as this one, of no particular merit, and indicating precisely the generalizing standards deplored by Agee, is lifted from its ordinariness by the way it collapses seventy-five years into seven. It is lifted also

24

Ann Carter and Lamb,

Los Angeles Times,

May 2, 1943.

Copyright 1943,

Los Angeles Times.

Reprinted with

permission.

82

by how it combines times, portraying the moment when grandmother becomes child and back again. Here is the uneasy relation of then and now that famously characterizes all photography from the pre-digital era.

Even so, the *Los Angeles Times* photograph is not an infinite image of time associated with Ann Carter. Was this infinite time instead the death of her character in *The North Star*? "I remember being killed," she says to me, describing the scene where Olga runs down a village street and is strafed by Stuka dive bombers. That scene required several takes, she remembers, since it was scary for her and painful to land on the hard ground amid the spurting packets of fake blood. Even after the crew placed a mattress sunken into the ground for her to fall on, they had trouble getting the synchronization of the gunfire right. Meant to kick up dust in a sequential pattern around her as she ran, the bullet explosions were out of step in an early take or two, requiring the technicians setting them off by remote control to refigure the layout. But this explosion of instants and Carter's memory of it somehow belong only to the world of anecdotal historical time.

The infinite is a single moment in a film Carter made later that year—a moment that suggests a strangeness of perpetuity foreign alike to historical anecdote and to Bourke-White's pizzazz of the Now. In that film, *The Curse of the Cat People*, we briefly see Carter's hand as she moves it through a small pool of water (fig. 25). In the film—actually quite a touching and subtle one, not scary at all, despite its studio-assigned schlock title—her character, Amy, has just received a magic ring from her imaginary friend, and she makes a wish as she waves her hand.

25

The hand of Ann
Carter in *The Curse of*
the Cat People (1944).

The scene is eerie. "The symbolized view of her arm in and out of the water produces a very strange, almost macabre impression," wrote *New Republic* film critic Manny Farber in his review of March 1944. The brevity of the enigmatic moment corresponds to what Agee would write of another film in 1945, that "somewhere close to the essence of the power of moving pictures is the fact that they can give you things to look at, clear of urging or comment, and so ordered that they are radiant with illimitable suggestions of meaning and mystery." Art is the hand without the lamb. The moment dilates in such pictures, producing a "very strange, almost macabre impression" perpetually at odds with the charisma of the present. In a film released during the same weeks in spring 1944 as *The Memphis Belle*, the

hand is the twirling bomber forever in its fall, five digits floating through space.

In 1943 Bourke-White was warding off this other time. The most well-known of the photographs she took at a steel factory in Gary, Indiana that year—photographs she possibly took going to or from Los Angeles—is an image of a woman welder hard at work cutting out pieces of armor plate for ballistics tests (fig. 26). Intended to illustrate the vital role of women in wartime factories, the photograph depicts twenty-year-old Ann Zarik, blind to all other concerns, focused on the job at hand. The sparks, a trademark of Bourke-White's industrial photography, flare in a darkness as enclosed as Zarik's goggles. In a self-referential image—Bourke-White also used her equipment to ignite sparks and help win the war—the job is not only to make the new but to exorcise all other worlds except the one immediately before one's eyes. The welder's torch is the photographer's tool of blindness, a means to make dazzling illuminations so self-contained and complete, so persuasive within their limited spheres, that they banish anything not happening then and there. Within that charmed blast of light, we need never contemplate what lurks in the outer rings of darkness.

Throwing sparks from the wand, Rosie the Riveter is a sorceress commanding death to go away.

On the set of *The North Star*, Bourke-White was herself warding off deep time. With her customary bravery, she "climbed catwalks over the sets with the agility of a Commando," according to a period description, and a publicity photograph shows her high up on a camera boom next to the film's accomplished cinematographer, James Wong Howe. The balance she maintained was always a graceful

cat's paw counter-sway to the rolling twirl of the globe, the slow rotation of eternal becoming. Holding her camera crucifix, she tried to vanquish another kind of time as well, one all around her as she worked: the slow decrepitude of rust, the flaking deterioration of obsolescence. As she sensed, this terror of time might creep up over a period of years or appear all at once, collapsing the ruin of centuries into a moment, making the solidest structure an instant pile of dust.

She lived in a great culture of the obsolete, one in which the concept was coming into its own, a flag atop each growing pile of industrial and commercial detritus. *The North Star* is a good example. Even the most generous-minded viewer watching the film now must wonder at the same oddity that troubled moviegoers then: notably, the *Oklahoma*-style musical episodes (incredibly, for the first thirty minutes, this film about the Nazi invasion of the Soviet Union is virtually a musical). The opinion of Lillian Hellman, who had written the script in 1942, is decisive. Summoned to Hollywood by Goldwyn via telegram on July 10, 1943 to see a rough cut of the film (much changed from her original conception), Hellman sat in the screening room and then, forty minutes into the movie, according to an account, "started to cry, first quietly to herself, then histrionically." Turning to Goldwyn, who was upbraiding her for weeping, she predicted the film's nearly instant obsolescence: "Don't tell me when to cry. You've turned it into junk."

What was new quickly became old, as Bourke-White understood. In 1938 she backed the stage adaptation of her partner Erskine Caldwell's novel *Journeyman*, maintaining her financial support despite conclusive evidence that she should abandon the theatrical flop. Caldwell's specialty was

26
Margaret
Bourke-White,
Steel Worker, cover
of *Life* magazine,
August 9, 1943.
Time & Life Pictures,
Getty Images.

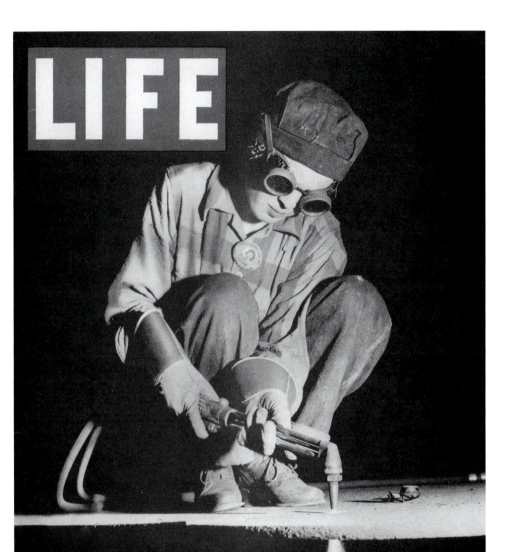

LIFE

STEEL WORKER

AUGUST 9, 1943 **10** CENTS
YEARLY SUBSCRIPTION $4.50

earthy depictions of sexuality, most notably in his novel *Tobacco Road* (1932) and in the Broadway adaptation of it that began its long run in 1933. Now, in February 1938, the raunchy *Journeyman* opened—to disastrous reviews. The play was about the wicked preacher Semon Dye, a "vicious and masterful charlatan who for six days of the week lightens his labors in the lord's vineyard by assaulting the women in the neighborhood, guzzling corn licker and cleaning out the Georgia crackers in a crap game," as a critic summarized. Such a plot did not suggest box-office success, but Bourke-White was convinced that it "should go in a big way," according to a friend, and she gave Caldwell $3,850 toward its production, much of the money after it was clear the play was a hopeless failure to be quickly and permanently forgotten. As a reviewer put it, Caldwell's wallowing in the human animal may "limit the possibility of very much future interest in his writing." Bourke-White, who married Caldwell in 1939 and divorced him in 1942, perhaps learned the lesson: what is racy and challenging, deliberately off-putting in a potentially ambitious way, can disappear even quicker than the most homogenous and disposable crowd-pleaser.

Lady Be Good—the movie and song that gave the ill-fated B-24 its name—fit into the latter category. The film portrays the song's popularity in a sequence showing crowds of customers striving to buy copies of the sheet music as multiple pianists in different music stores frenetically play the catchy tune. We see rising stacks of sheet music, accompanied by a thrum of falling coins, then dollars floating down like autumn leaves, as consumers jostle to get their hands on the new sensation (fig. 27). Yet watching

27
Proliferating sheet music in *Lady Be Good* (1941).

the film now is to see a picture that comes as though from an ancient civilization. The confident hit song, though still catchy, is eerily surrounded by signs of its own immolation: the magical proliferations of music and money feel like a Midas touch, a curse. Here today, gone tomorrow.

In the desert the B-24 *Lady Be Good*, too, had a short life. Rolled out of the factory in San Diego in December 1942, it lasted for just the one mission some four months later. The plane endured longer, however, than many of the B-24s and B-17s that made it through the war untouched, since so many of them were consigned to so-called bomber grave-yards at war's end and broken up for scrap, ironically making the *Lady Be Good*, intact in its desert preservation, a survivor. But the song and the movie and the plane *Lady Be Good* all

tell us about the culture of obsolescence in which Bourke-White worked. Deep time laughed last, or "Dp" time, to give the first name of the *Lady Be Good*'s navigator, Dp Hays (third from the left in the crew photograph)—a seemingly old-looking young man, aged only twenty-four but looking about fifty in the picture, who had never been given a proper first name at birth, only the initials Dp (the crew called him Deep). Hays, "a Father Time figure," in the words of Mario Martinez, played a crucial role in getting the plane lost.

The thought was unthinkable, but maybe even Bourke-White's Now would rot away. *The Sky's the Limit*, a film from 1943 with a Bourke-White-inspired character, is one of those movies where night looks like poorly lit daytime, and daytime like darkness. The gloom is broken only by intermittent glimpses of snappy shoes and the spangled dress of some ingénue. What would be preserved? Back home in Darien, Connecticut, in late May 1943, Bourke-White received phonograph records of the lecture she had given in Los Angeles: "The smaller ones are for playing on your home phonograph," she was told, "and will stand about thirty playings." She received larger records, too, ones better able to withstand time, but on those smaller records the lecture—her voice—the history—the firsthand account of her experience aboard the B-17 above Tunis—would all grind down, deteriorating, slowing, losing coherence in time. Her war pictures, too, can seem a little dated. The journalistic Now, being so disposable, kept close company with magazine graveyards. The enthusiasm of the times was limited. What moments would last beyond their moment?

Maybe Bourke-White thought of this after her trip to Los Angeles, in keeping with the generally grimmer tone

of American propaganda in the later part of the war. One candidate for a lasting moment is a picture she made on her next trip into combat zones. In September 1943 she arrived back in North Africa, then crossed to Italy, where the Allies had recently landed and begun their long, slow, horrific drive to push the Germans out of the peninsula. Starting from Naples, by then heavily damaged by Allied bombing and booby-trapped and blown up by the retreating Germans, Bourke-White soon was at the front and flying in a tiny reconnaissance aircraft, an L-4 Grasshopper, taking photographs at low altitudes of the battle zones. One of these photographs, showing patterns of huge bomb craters on an abandoned airfield (fig. 28), is among the first pictures in *They Called It "Purple Heart Valley,"* the photo-book she published in 1944. Did this photograph do more than report the scene? Did it show a deep time?

The airfield looks like a lunar surface. "Wherever we flew we found the face of Italy scarred like the face of the moon," reads Bourke-White's caption below the photograph in the book. The moon always had an elemental fascination for her. "A comet took me up to the moon / And it left me far too soon," she had written in a juvenile poem preserved among her papers. "I am ringing a bell / As my farewell befell / When I fall down from the moon." Near the end of her life, in the postscript to her 1963 autobiography, she wrote of her "moon plans," noting that she had "asked for and received the *Life* assignment to the moon, as soon as we could get transportation. My dearest hope was that the science of space travel would advance enough in our lifetimes to enable me to carry out the assignment."

The bombarded cold surface of that lifeless rock was her ideal high. Maybe it was even the emblem of the lunatic wish, the death wish, that would send her up over the Italian front in a tiny unarmed plane. Bourke-White's zest for life— she had brought a dress from Adrian of Hollywood to wear on nights out in ruined Naples—might take some especially dark form when she was in an airplane. So what vision did she see above that airfield? Pulled as though by gravity to portray her own muse, perhaps she made a photograph of the end—a world without life—without her—the greatest and bravest kind of picture being one that courted oblivion. The Now, to avoid becoming obsolete, would need to show a deep time that Bourke-White instinctively avoided.

But is there oblivion in the photograph of the Italian airfield? The design of the image would suggest not. The bomb craters are among the many circles Bourke-White portrayed in her career—the circle being the prime element of her design vocabulary, her preferred means for beautifying many an industrial element, from pipes to engines to pails. She learned circles from the great pictorialist photographer Clarence White (no relation), whose work she admired for its strength of design and composition. White's circles are things of beauty, the rings of the ring-toss in his most famous photograph, the crystal ball in other pictures, the saucers of milk and lily pads in the work of his students—and Bourke-White turned the perfection of these designs to good account in her industrial photographs, including this one of a bombing pattern. Here too, as in so much of her work, American industry, hitting its targets, is a thing of beauty.

And so there is no oblivion here. The bomb craters call to mind the circles Bourke-White depicted in a 1929

28

Bourke-White, *Wherever we flew we found the face of Italy scarred like the face of the moon*, ca. 1943–44. Time & Life Pictures, Getty Images.

photograph of watch hands at the Elgin National Watch Company (fig. 29). Showing how the watch hands require flecking with luminous enamel paint, the photograph makes these icons of time into a seductive array of wide eyes batting their cactus lashes, a glitzy chorus of prancing showgirls as in a Busby Berkeley close-up, via Dalí. The photograph appeared in the April 1930 issue of *Fortune*, accompanied by Archibald MacLeish's short essay "Bottled Time," a title that says a lot about the glamorous seduction of the moment in Bourke-White's work.

MacLeish, who visited the factory with Bourke-White in 1929, distinguishes in the essay between bottled and raw time. "To the watchmaker, time is a commodity extracted from the universe and bottled for domestic needs." It is different from the raw time of the universe, which is not really time at all. Focusing on the watch company's astronomer, Mr. Urie, who attempts to determine sidereal time—time as measured by the stars—MacLeish notes that the "commodity [Urie] so carefully extracts from the stars is almost certainly not there at all," that physicists would not agree that there is anything like time actually out there to be recovered, and that Urie is consequently "like the fisherman who scooped his shadow from the sea . . . a harvester of illusion." But MacLeish concedes that time is "the prime necessity of our age," and so he grants the astronomer his illusory exactitude, and the factory its way of synchronizing the reputed time of the stars with the time of its watches.

Bourke-White's watch photograph is about the factory's bottling of time. It also implies that photography itself cannot help but be a bottling of time, something like Dorothea Lange's idea that being a photographer was like trying to catch lightning in a bottle. But what about time in the raw? A few years before the Elgin Watch essay appeared in *Fortune*, MacLeish wrote his most famous poem, "You, Andrew Marvell," about the turning sensation of cosmic time experienced by one person as night comes on. The poem begins:

And here face down beneath the sun
And here upon earth's noonward height
To feel the always coming on
The always rising of the night

29

Bourke-White,
*Flecking of watch hands
with luminous enamel
paint, Elgin National
Watch Company*, 1929.
Margaret
Bourke-White Papers,
Special Collections
Research Center,
Syracuse University
Library. Copyright
Estate of Margaret
Bourke-White/
Licensed by VAGA,
New York.

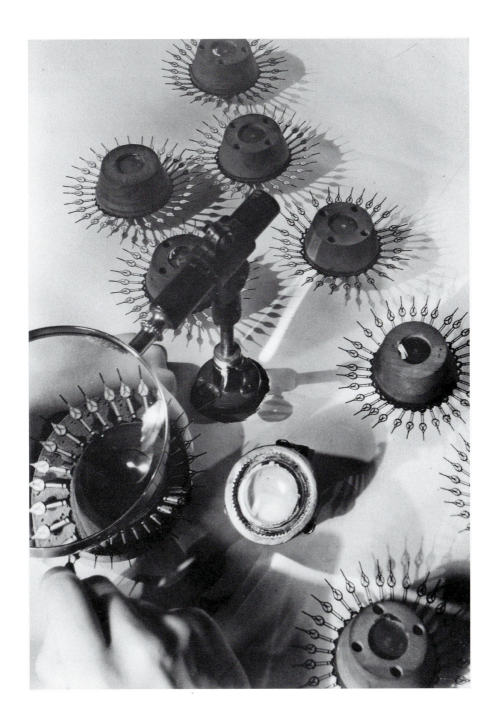

And it goes on to describe the flood of darkness across the world, from location to location, as this person senses it, until we come again to the person feeling the earth turn beneath his body:

> And here face downward in the sun
> To feel how swift how secretly
> The shadow of the night comes on . . .

MacLeish's raw time is an homage to the seventeenth-century poet Andrew Marvell and his famous poem "To His Coy Mistress," with its lines

> But at my back I always hear
> Time's winged chariot hurrying near;
> And yonder all before us lie
> Deserts of vast eternity.

MacLeish and Marvell write about the oblivion hastening daily actions, the way it quickens to sensuous life the motions of the moment, as if fingertips on skin—to touch the lover—must be lit by all the horizon's light. Bourke-White's photograph of the bomb craters likewise portrays a type of outer space that might intensify the experience of the person who senses it. Yet the photograph remains a story only of this world, of the urgencies of its time. In the wildness of the air, there was a Now for every tick of the clock, a chance to be carried away at each waking hour, and never a moment to be lost.

Sentimental Mysticism
Stovall at Archbury

At the start of the 1949 film *Twelve O'Clock High*, an American gentleman emerges from a London hat shop, having just purchased a hat. It is four years after the war. Thanking the proprietor and his assistant, the man prepares to be on his way (fig. 30). In this movie about combat trauma, we will understand that the man's visit is psychological—he has just had his head examined, and in a lengthy session. Parting ways with the milliners at the door, the gentleman tells them that he is grateful they have spent an hour and forty minutes with him, when back home a similar purchase would have taken five minutes. We gather that in America he would have gotten a quick sensible talking-to, some efficient practical wisdom, but in London he has received a royal treatment befitting an establishment whose door-sign proclaims it purveyor to the king. The English hatters are mad, but these eccentric men have restored the American to his senses, and he moves down the street, right as rain.

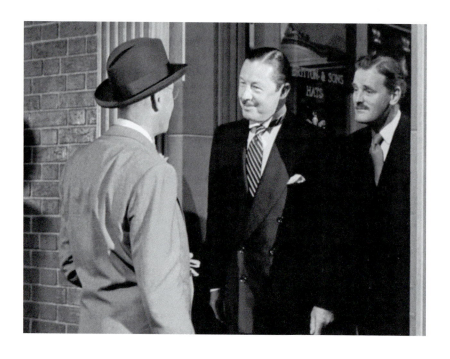

30

Stovall (Dean Jagger)
with hatters in *Twelve
O'Clock High* (1949).

Then something happens. The American takes a few steps and pauses to look at his new self in the mirror of the antiques shop next door. As he prepares to keep walking, however, he gives a start. There in the window, down below his reflection and amid the assorted bric-a-brac, he spots a crude painted jug—a Toby jug, the type is called—with Robin Hood features. Immediately entering the store, the American directs the owner to retrieve the jug so he can see it closer, affording us a brief good look as well (fig. 31), and then he buys it, telling the store-owner to pack it up "carefully, very carefully."

What is this about? In psychological terms, the American has had a relapse. The hour-and-forty minute session at the hatters' next door has made him a new man for all

of about three seconds—just long enough, in proverbial terms, for him to make it one address down the street. There the sight of some old temptation—here a big shiny jug—is intoxicating. The new man immediately reverts to his old self, doing so irresistibly, despite the best of care, sodden with the leering piratical head he cannot resist buying.

The jug holds his war memories. The American travels with it to an abandoned English airfield, and there he undergoes a flashback telling us all we need to know about the trauma whorled from the grinning vessel. In a past made visible, drawn from the head, the long grass bends, the deserted place chokes to life, and we see B-17s returning from a bombing mission. One is damaged, landing without wheels. From this plane a pilot with a severe head wound is carried out, jabbering and talking crazily. "You can see his brain," says a man at the scene. The Toby jug, with the top of its head missing, is likewise a damaged mental object.

31

The Toby jug in
Twelve O'Clock High.

The hat-buyer, whose name is Stovall, was once a major at this base, and as someone who helped attend to the fatally wounded pilot he is seeing it all again, including his old self, across a distance of seven years. He will go on to recollect much more as the movie continues, especially about General Frank Savage, played by Gregory Peck, who suffers the biggest mental breakdown of all. Like so many other films from the late 1940s, *Twelve O'Clock High* is about getting inside traumatized people's heads.

But the opening sequence is more than psychological. The American gentleman is also a historian. From the relative safety and security of London in 1949, he delves into a past broader than his own memory, and his vision, starting with this flashback, lets us see the whole historical world of American bomber command in England, ca. 1942. He is however a particular kind of historian. He is not one for documents and archives. The only writing he consults as he makes his backward journey is the station name of the town where the airfield was based, "Archbury," seen once on the train platform and again, spelled out in faded whitewashed rocks, on the ground of the airbase. The American is not an archivist, but instead the kind of historian who perceives the past via a direct and devastating chance personal impression. Walking down the street, minding his own business, he happens to see an object that to others—the storeowner, for example—is a meaningless piece of ephemera. "I'm afraid it's not much value," deprecates the owner, but the American sees in it extraordinary worth. As the very jug that stood on a mantel at the officers' club at his base during the war, it used to indicate when there would be a mission or not. Turned away from the room, the jug told that there

was no mission; turned face front, it said there was. Now, with this personal object in his possession, the intuitive historian knows something else. He must go to the spot where the airfield was, repatriating the jug with its original surroundings, if the volatility of the past is to emerge from his head. So he gets on the train and goes back to Archbury, where the jug will be his Aladdin's Lamp.

There, having exited the train, he rides a bicycle to the airfield, the neatly packed box containing the jug in the basket between the handlebars, and dismounts at a rustic wooden fence. It is a sunny day and pleasant music plays on the soundtrack. Next he strides out alone across a field of tall grass, past some grazing cows, and the music becomes ominous and the skies suddenly gray, until he comes to an abandoned runway (fig. 32). There he contemplates the deserted scene of an intensified past—the place where so many of his friends and comrades lived and died. We start to hear the drone of engines as the American removes his glasses and cleans them with his handkerchief. He wants to see clearly as he is taken back in time. Turning slowly in a circle, doing so within the concrete round of an old airplane parking pad, he performs an incantation that makes the winds rise (fig. 33). The tall grass waves around him in the wash of propellers choking and thrumming to life (fig. 34), and when the camera turns back to where he should be, he is not there. We are in the past.

Stovall is the type of historian who is a Romantic poet, a lone wanderer in the English countryside. The oil-stained runway of wet reflections is his Tintern Abbey, triforium and clerestory flattened to a pavement no less expressive for him than ruined spires were for Wordsworth. Motivated

32

Stovall at the
Archbury airfield in
Twelve O'Clock High.

by personal association and deep feeling, he moves through a sympathetic universe, exposing his brain, responding to his emotions. The great waving of the grass is an index of his projected mental powers, in the best Wordsworthian manner, the past coming to life thanks to the vivacity of his sympathetic imagination. But Stovall is also a big step down from a Romantic wanderer. From the first, we see that there is something fatefully mild about this man elected to be our guide to the past. As played by Dean Jagger, Major Stovall is asexual, a milquetoast. In the 1948 book by Beirne Lay, Jr., and Sy Bartlett on which the movie is based, Stovall is a lawyer from Columbus, Ohio, who at the hat shop is careful to choose a chapeau that will not cause too much of a stir back home. He is concerned about proprieties in a way that most Romantic poets would not be.

The movie includes a sleight-of-hand that shows just how mild the man is. After he directs the antique-store

33
Stovall slowly turning in a circle in *Twelve O'Clock High*.

34
The grass blows back in *Twelve O'Clock High*.

owner to pack up the jug, we never see it again in those opening scenes. Stovall keeps it neatly inside a box on his lap as he sits in his train compartment on his way to Archbury. We next see the box in his bicycle basket. Then, when he leaves the bicycle at the fence, he leaves the box there as

well. The gentleman's vision of the past, which we assume to be precipitated by the Toby jug, in fact takes place with the jug excised from the scene—checked at the door, left at the fence. Containing a volatility too great and crude for the proceedings at hand, the jug remains on the sidelines as the man experiences his historical vision.

And the terms of that vision, now that we think of it, are too fastidious and prim for so grass-ripping and thunderous an epiphany. Wiping his glasses with his handkerchief and wearing his proper new hat, Stovall performs a disappointingly anticlimactic historical transformation. As transitions go, the phone booth of this Clark Kent is a parlor of almost Victorian propriety, and we suspect that we are to receive a historical vision to match. True enough, his attitude evokes not only the largely decorous tone of the ensuing film but the stately words we see after the opening credits roll and before the hat shop sequence unfolds: "This picture is humbly dedicated to those Americans, both living and dead, whose gallant effort. . . ." Likewise, the choice of a name for the air base, Archbury, conveniently splits the difference between commemoration (Arch) and death (bury), as if the film were determined to be neither too grandiose nor too morbid but to operate in some respectful middle ground between the two. Stovall's historical inquiry is ceremonial and definitive, a dignified method of both praising and burying the past.

The start of *Twelve O'Clock High* contains another sleight-of-hand evincing Stovall's historical method. As he begins his flashback, the engines come to life and the waves of grass indicate planes starting to taxi before taking off. But when we move in a moment back into the past,

the B-17s are descending, preparing to land. The difference is significant. Poetically, lifting off is a sign of liberation, ecstasy, religious ascension. The chariots wheel and the putti abscond, and the cloudlets seem glad amid the puffy-cheeked and roseate glories of a person leaving the earth. No wonder Stovall's revelation is a take-off. But coming back to earth is about coming to your senses, back to cold hard realities, bringing an imaginative flight to a definitive end. No matter how welcome such returns were for actual aircrews during the war (and how full of dread their take-offs were), poetically the terms are reversed. Taking off is a sign of possibility and abandon. Landing is a sign of conclusion and retrospect. When the returning planes come to a stop in that opening scene, they are palpably historical relics—in 1949 it was difficult to find B-17s, and the film's production crew managed to drum up only twelve. When the flight crew emerges from the damaged B-17, the grass and light feel dusty, and the old beaten-up plane is dirty. Stovall's flashback renounces its own imaginative energy in favor of the historian's penchant for dry conclusions.

Stovall's historical vision is a sign of how the war was remembered in 1949, a point underscored by the location of his walk. Filmed in Alabama, where the producers found an old airfield that looked more like England than the California location where they had originally planned to shoot the scene, the opening of *Twelve O'Clock High* is a fair homage to the mid-century glories of the well-to-do American white man. With people at his beck and call, treating him like a king, putting a crown on his head and answering to his whim, he is free to be the master of a universe of melancholy beauty and historical recollection. To him life is

good, never better than in his moments of sad sensitivity and reflection. It is no wonder Dean Jagger won an Oscar for best supporting actor. The only problem is that given room enough and time Stovall has produced a poetic history that reflects the complacency of a person too alone and unchallenged in the privilege of his certitudes.

Meanwhile, what has happened to the jug? The film cannot quite evade this scary object. Yes, it sits neatly boxed on Stovall's lap on the way to Archbury, but the train whistle blows as we see it sitting there, sounding like the throttled shriek of the head. It will out. Then, left at the fence, the jug is still implicitly the force that drives back the grass, the only object with a power talismanic enough to unleash the furies of memory. The movie, however, sides with the hat shop. It wants to restore proprieties by hiding this shiny and pornographically evil artifact and its capacity to hold the war's open wound. The movie instead conceives the war in terms of the feel-good gallantry of an Anglo-American exchange, and even anoints the behatted American the new monarch of the post-1945 world, the crown having passed from one country to another. But the Toby jug is the crude totem of deeper and more disturbing recollections. Ribald and cheap, it is to be kept well boxed lest it prove too much an embarrassment for the gentleman, but this low-class gimcrack is a bit of mummery from which a robber's grog of screwing will flow. Sensuous, brainless, smiling lasciviously, the decapitated head of the brigand is a life from beyond the grave, pouring out blurry visions of how it was, in a slurred speech that is the opposite of refined eloquence. The movie, having introduced such a figure of historical memory, cannot quite keep it contained.

The jug's wild companion is the open field, the long grass blowing. The film must manage the field as much as the jug, populating the emptiness with the returning planes. It cannot acknowledge that the open field is where the past appears in its true condition. The sense of being where something is no longer present is what inspires the historian. What causes a place to vibrate with its former life is the continuing meditation on the actively open field of absence, and not the desire, however inevitable, to fill that blankness with images of what happened there, as Stovall does. The historian's gaze is a lawnmower that grows the grass.

This empty place cannot be accessed except by personal sensation, yet what is envisioned there is not psychological. Seeing one's brain is not the point of being in an expansive clearing. Instead the revelations are breathtakingly and liberatingly outside oneself. They are about space—space as something exhilaratingly around and outside the envisioner, just as the sweeping grass around Stovall is finally a phenomenon separate from his mental powers. Closed historical spaces open up in visionary moments, appearing in arcs of narrow but extraordinary clarity. The visions feel religious, the ecstasies of a fasting nun weeping to match the tears squeezed from a Madonna's stone face. There is not much to see in these glories of the imagination—no full-blown costume drama of people dead and gone—but instead just the sense that a gust has rippled the grass. The energies are disreputable and naïve, the feeling superstitious. But such moments are not about dignity and decorum. They require taking off the historian's hat.

There is only one catch for me—I do not like this Toby jug. The jug is too evidently the sign of a roistering masculin-

ity that I cannot identify as my own, even in alter ego form. Looking at a replica Toby jug now housed in a small museum at Thurleigh, England, the site of the airfield where the events inspiring *Twelve O'Clock High* took place, I am confronted anew with how foreign and frightening it is to me (fig. 35). The fact that seven identical vessels were used during filming makes the jug stranger still. It is not pretty to think of the mass production of these multiple brothers of bad recollection. I am not moved by this object. I do not love it.

Maybe this is because the grinning head is a false or partial muse of history. In a way that is typical of 1949, *Twelve O'Clock High* recalls the war in almost exclusively male terms. The only female character is a nurse who plays a small part in one scene. Producer Darryl Zanuck cut the female love interest who appears in the novel and in the

35

John Rampley,

Toby jug, 306th

Bombardment Group

Museum, Thurleigh,

England, 2009.

Courtesy of John

Rampley and the

306th Bombardment

Group Museum.

original script, citing the confusion that such a subplot would cause, but the omission indicates more than the requirements of a crisp story. The film imposes a symbolic quarantine—the war is recast in the late 1940s as an arena of male psychology—but this was not the way the war was depicted while it was fought or anticipated.

Back in 1941 Beirne Lay, Jr., had helped write the script for the aviation film *I Wanted Wings*, based on his book of the same name, and in that war-preparedness film there are not one but two important women on the air base and even on the planes. One is a Margaret Bourke-White character, the photographer Carolyn Bartlett (Constance Moore), identified as the maker of famous pictures of "Kansas corn silos" and "steam turbines," whom we first see glamorously snapping her shots of a silver warplane's streamlines. She is "photography's dynamic symmetry girl" who has come to the airfield "to make a series of pictures for a national magazine," and the airplane's strong lines are nothing next to her nylons. The second is the astounding Veronica Lake, in one of her first roles, who plays the fatale nightclub singer Sally Vaughn, a disastrous stowaway on a B-17 during a simulated combat mission.

Aviation and women went together in 1941, but eight years later, in Lay's *Twelve O'Clock High*, there are virtually no women to be found. The same is true in *Command Decision*, a similar bomber movie that MGM released in 1948, where women, when we hear of them at all (we never see them), are kept in the margins of the air base's charmed circle. Even the notorious homespun paintings of women that decorated the nose sections of American bombers are absent from these films. Where are the vernacular Vargas

girls, lounging in their negligees and swimsuits, floating up-side down as though suspended from invisible trapeze bars, pendulous with their unwieldy anatomy? Where are these figures that make one think of a technical sergeant with a self-claimed knack for the paintbrush who with nothing more than a few hasty look-sees at an art correspondence school lesson cribbed from the back of a buddy's comic book deigns to deliver these shocking vamps to the sight of German pilots who, if they glimpsed them at all, must have despaired of the state of American pornography? Instead all we see are prim airplane nicknames, often with no accom-panying art. Hollywood proprieties and decency require-ments aside, where are women, any women, in these films? Understandable as it may be in movies that focus on the experience of all-male combat crews, the choice nonethe-less feels like a deliberate omission, a rewriting of history.

Why is this? Yes, in the late forties Rosie the Riveter had long since returned to the home. The economic and sexual lib-erty that the war represented for so many American women was mostly a thing of the past, and the lack of a feminine presence on the airbase and even on the aircraft in *Twelve O'Clock High* and *Command Decision* was part of this social retrenchment. But something else was at work as well—a force that had less to do with gender politics than with some deep and superstitious sense of how the war was *experienced*, how it had been felt and known: namely, through magical images of women. The face of a female movie star—that of Judy Garland in a scene from the 1945 film *The Clock*, for example (fig. 36)— said much that was unspoken in those years—gathering to itself a million joys and tragedies.

The critic James Agee wrote approvingly in 1945 of that scene in *The Clock*, noting its "sentimental mysticism." Garland's character approaches her soldier lover in a midnight park for a first kiss with him, and her face, like his, appears in close-ups "boldly and successfully unrealistic." The scene, for Agee, produced "at once a remarkably deep and pure power of the moment and of the individuals, and a kind of generic pity and majesty." Both the players achieve this effect—Garland's costar Robert Walker as well, but it is she who stands out for her power to envision—and make us see, too—what is not there. Like Dorothy singing "Somewhere over the Rainbow" in *The Wizard of Oz* (1939), Garland portrays faraway worlds in her face. In wartime, hers was the sheer strength of a hallucinatory faith, as though the actress conceived her war-bride role in *The Clock* as a chance to make her body into the saintly switching station for all the emotion, all the pathos, intuited and palpable,

that she regarded as her patriotic duty to turn into an aesthetic form. The girdle of carpentered trees on the back-lot set becomes a *hortus inclusus* that this virgin must penetrate for her vision of a wide world to be immaculate.

It is this type of talismanic presence that in 1949 *Twelve O'Clock High* must renounce. Sentimental mysticism remains—what is Stovall's walk at the airfield but that?—but the ugly mug has usurped the place of the woman as the face of war visions. The result is a careful, somewhat persuasive, but finally false recasting of wartime experience as *not* dependent on the superstitious power of a woman's image. Even now, the faces of these women—encountered by chance in a window of forgotten things—glimmer with the visionary power they once had, awaiting the notice of some sympathetic passerby to unfold that power again.

37

Marion Hargrove
(Robert Walker)
and Carol Holliday
(Donna Reed)
in *See Here, Private Hargrove* (1944).
Photofest.

Consider three examples. Each comes to me by chance, and each is about being a movie fan, though I am not necessarily the fan in question. The first concerns Donna Reed, who began her film career in 1941 and appeared in increasingly substantive roles during the war and right afterward, leading up to her star turn in the now-famous film *It's a Wonderful Life* (1946), where she plays the female lead opposite James Stewart. Several years ago I met Reed's youngest daughter, Mary Owen, by happenstance—a friend of hers had attended a talk of mine and arranged for us to meet—and soon I was reading the letters American servicemen had written to Reed during the war, which Mary keeps carefully preserved in three large binders.

What struck me as I read them was less the men's devotion to Reed than the places they wrote from, the locations where they saw her films. These include spots in the

United States ("the wilds of Maine") and many combat areas abroad: Sicily, France, England, Anzio, the Aleutians, "the middle east," "somewhere in the South Pacific," "somewhere in New Guinea."

Many of the men describe the places where they watched a film of Reed's that they especially loved—the now mostly forgotten comedy *See Here, Private Hargrove* (1944). In that movie, Reed's biggest role to that point, she costars as Carol Holliday, the girl-next-door love interest of Private Marion Hargrove, played by Robert Walker (fig. 37). Hargrove is a journalist turned soldier, undergoing basic training at Fort Bragg, North Carolina, and the humor of his mishaps made the film a big hit at the time, though now it

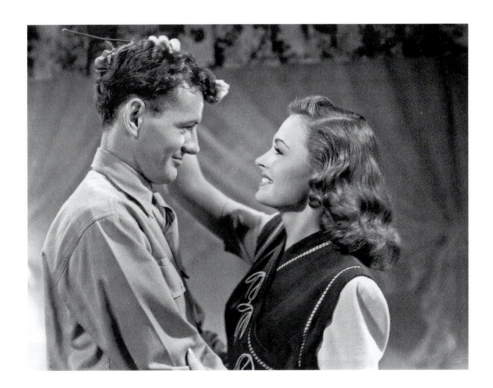

is obscure and a bit forlorn. In retrospect the movie even seems to be aware of its limited worth, since the running gag is that the journalist Hargrove is forever polishing garbage cans as KP penance for his soldierly ineptitude and misdeeds, all the while staring at his image in the blurry metal, much to the delight of his pal Private Mulvehill (Keenan Wynn). In a film that mentions *Moby-Dick* and includes this Private Mulvehill (an odd distortion of Melville), we understand that the writers of this story about a writer are not out to make an American classic. Like Robert Walker, they are simply doing the best they can with the disposable materials they have been given: namely, polishing the garbage cans in which they good-naturedly but ruefully see themselves as they work. But Donna Reed's fans loved her in the film, where she is affecting in the underplayed role of a soldier's ideal sweetheart. And her image in that role played around the country and the globe, attracting actual servicemen and bringing to light specific places in their letters.

New Guinea stands out for me in the soldiers' correspondence. Through their writing—and finally through Donna Reed herself—I start to see something of it. One man describes watching *See Here, Private Hargrove* "in a drenching rain." Another says: "We enjoyed the picture so much, that we got through our usual nightly downpour of New Guinea Rain." Another speaks of how "last nite we sat in the front row of our makeshift theater, thoroughly enjoying" *Hargrove*. Another describes walking two and a half miles to the theater to see Reed's film a second time the night after first seeing it. Another says, "I have been an admirer of yours ever since I saw you in 'See Here, Private

Hargrove' while I stood in six inches of rain. Incidentally, I saw that picture four times." And yet another gives a glimpse of the soldier's situation while viewing: "I saw the picture about 50 yards away, from the side of an angle of 30 degrees, and the leading lady as I could make out from the side was you." For me the letters give a glimpse not of Reed herself, and not of the soldiers, but of the environments in which they saw her film.

By the thrown light of her filmed image, rebounded back from a temporary screen in the jungle, I see the illuminated surfaces of bark and roots, the floating leaves of a water plant, the blackish-gray trunks of the trees, not to mention small shrublike herbs, with broomlike branchlets; then, closer, brown bristles on leathery pods dangling with ovoid seeds. I start to see, though impossible, the actual image of Reed reflected on the parasitic vines and bitter-tasting stems, the serrated edges of the velvet ferns, the tufts and the spikes and the blue flowers bunched at the edges of the larval ponds. I see her on all the bulbs, twigs, and rubbery fronds, each one bearing a tiny image of her down to the hairs on her head, or perhaps just a fragment of her picture flowing just then on the screen. The vision is the opposite of history, the opposite even of the letters that occasion it. Without meaning, it is a graffiti proliferating on the other side of silence, a writing that cannot be seen. It has no value except this: it allows me to see a moment and a place in the past, reflected in its own light.

My second example concerns Anne Frank. I am in Amsterdam for a conference, and I go to the Anne Frank House. The museum at 263 Prinsengracht is the location of the Frank family's Secret Annexe during the war, the set

38

Priscilla Lane (left)

and Rosemary Lane,

wall of Anne Frank's

bedroom, Amsterdam.

By permission of the

Anne Frank House.

Premium Archive,

Getty Images.

of rooms in which they hid from the Nazis from July 1942 to August 1944, when they were discovered and eventually sent to different concentration camps, Anne and her older sister Margot dying of typhus in Bergen-Belsen in March 1945. At the museum I learn that Anne Frank was a movie fan, and that among the photographs she pasted on the wall of her bedroom in the Secret Annexe was one of the American film stars Priscilla and Rosemary Lane. The photograph of the Lane sisters was discovered only many years later during a restoration, when some of the pictures on Anne's bedroom walls were found to have been superimposed over other images. The Lane sisters were found beneath a picture of the face of Jesus in Michelangelo's *Pieta*. Images show the two photographs, now separated, each against the wallpaper of the bedroom (figs. 38–39).

Michelangelo over the Lane Sisters—high art replacing popular culture, the life of the mind over fan enthusiasms: the superimposition marks the fourteen-year-old Anne Frank's increasing seriousness. She had wanted to become a Hollywood actress and used to look forward to receiving the Dutch fan magazine *Cinema & Theater*, smuggled into the Annexe every Monday, but little by little her tastes were changing. On May 8, 1944, slightly less than three months before her capture, she wrote of her postwar plans: "I'd like to spend a year in Paris and London learning the languages and studying art history." Thoughts of a movie career were fading. When on December 24, 1943 she wrote a story called "Dreams of Movie Stardom," the tale reported her change of heart.

In the story a seventeen-year-old Dutch girl named Anne Franklin is cleaning out a closet when she finds a shoebox

39

Face of Michelangelo's

Pieta, wall of Anne

Frank's bedroom,

Amsterdam. By

permission of the

Anne Frank House.

Premium Archive,

Getty Images.

Rosemary en Priscilla vol-gens een zeer recente op-name. Geen van beiden denken zij nogaantrouwen. Priscilla beweert althans dat zij minstens nog een jaar den tijd heeft. Rosemary laat zich weinig of niet over haar privé-gevoelens uit. In filmland gaat echter het hardnekkige gerucht, dat zij iederen keer na een radio-uitzending (beide zusters zingen namelijk veel voor de Ameri-kaansche radio) een geheimzinnig tel oontje uit New York krijgt.

Een detail van het beeldhouwwerk „Pieta"

"with the words MOVIE STARS written in large letters on the lid." Inside she discovers an envelope containing photos of the Lane sisters, including an address, and resolves to act, writing a fan letter in English to the youngest Lane sister, Priscilla. The two become pen pals, the movie star even asks to be called by her nickname "Pat," and then something still more remarkable happens.

Priscilla asks Anne if she would like to fly to Hollywood and spend two months living with the Lane family. Anne is thrilled and soon after she arrives (following a five-day trip), she and Priscilla go to the beach and take sightseeing tours during the actress's two-week vacation. Anne even seems ready to become a movie star herself—Priscilla invites her to Warner Brothers and encourages her to take a screen test, and Anne gets a starter job posing for tennis racket ads. But the job turns out to be a bore and a physical challenge, and seeing how weary Anne looks, Priscilla forbids her to work anymore. The Dutch girl enjoys the rest of her California vacation. But "as for dreams of movie stardom, I was cured."

No wonder Priscilla Lane is pasted over with Michelangelo. For someone who never visited Hollywood, Anne Frank had a wise sense of the limited and degrading opportunities the movie industry afforded. But then again, the photograph of Priscilla and Rosemary Lane is not so easily dismissed. As a composite with Michelangelo's *Pieta* on Anne Frank's bedroom wall, it suggests that starlets also had their pathos, that Hollywood pictures drained the eyes of their tears and the veins of their blood. Priscilla Lane, seen through the eyes of Anne Frank, becomes a projection akin to Donna Reed in the soldiers' letters, lighting up a lost world in a vision.

Again, it is a matter of space. Frank's adoration of Priscilla Lane makes me think of two movies Lane starred in that Frank never saw: *Saboteur* (1942) and *Arsenic and Old Lace* (1944). The first, released three months before Frank and her family went into hiding, is about public space. Starring Lane as Pat Martin, a young advertising model who falls in love with a nice guy wrongly accused of sabotage, it ends with a famous sequence atop the Statue of Liberty. In that first full American year of the war, public symbols of freedom and patriotism loom large. How different it is in the second film, released two years later, which is all about enclosed and secret space. *Arsenic and Old Lace*, a comedy, was first shown in September 1944, the month the Franks were deported from a Dutch holding camp at Westerbork to Auschwitz. The *Motion Picture Herald* review of the movie appears in the September 2 issue; the Franks boarded the train for Auschwitz, the last one sent there from Westerbork, on September 3. *Arsenic and Old Lace* is not only relentlessly about private space. It is also about how murder and history lurk there.

In an old house in Brooklyn, Aunt Abby and Aunt Martha live by themselves. Kindly and eccentric, beloved by the policemen on the beat, the elderly aunts have a secret: they kill people. Slipping poison into the elderberry wine they offer to old, downhearted gentlemen drawn to their house by a sign advertising a room to let, the aunts kill them out of kindness and take pride in the act as a work of charity. One of the dead bodies, that of the most recent elderly gentleman, is temporarily stashed in the window-seat as the movie opens, but all the rest are buried in the cellar, where the aunts' delusional nephew Teddy, who thinks he

is Theodore Roosevelt, has interred them in the belief that he is digging the Panama Canal.

Teddy is one of several historians in the film. A student of the past, he knows the subtleties of turn-of-the-century presidential protocol, and he recalls San Juan Hill with every running charge up the stairs. In his delusory identification with the past, so complete that he wears the Rough Rider uniform of the long-dead president, he is a re-enactor whose throaty, historically accurate screams—evincing a full emotional connection to long-ago events—attract the ire of the neighbors and eventually get him sent to Happydale Sanitarium.

The other historians are almost equally crazy. The aunts take a great interest in the past, empathetically imagining the travails of the lonely old men. Jonathan, Teddy's crim-

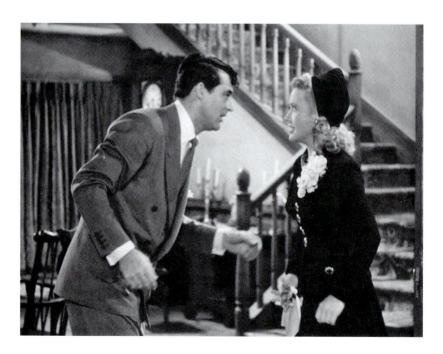

inal hoodlum brother, recalls the worldwide locations of
every murder he has committed, his memory assisted and
corrected by his traveling companion, the plastic surgeon
Dr. Einstein. And Mortimer Brewster, their foster-brother,
is driven daft as he pieces together the history of the aunts'
murderous habits. Only Elaine Harper, played by Priscilla
Lane, remains sanely concerned with the present for most
of the film. Focusing on her impending honeymoon trip
with Mortimer to Niagara Falls, she does not realize until
the end the true history of the murderous private place
where she finds herself (fig. 40).

That place is the large front room of the maiden aunts'
house, where most of the action occurs. Serviceable and
sturdy, the set for that room evokes the Broadway play on
which the film was based. A static location, it brings to

41
Dr. Einstein (Peter
Lorre), Jonathan
Brewster (Raymond
Massey), Martha
Brewster (Jean Adair),
and Abby Brewster
(Josephine Hull) in
Arsenic and Old Lace.

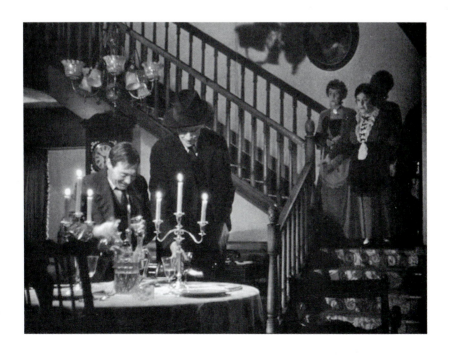

mind the premonitory feeling of a theatergoer who arrives early for a show and examines the props on a curtainless stage. The stairs announce Teddy's charge before he has ever appeared, and we know the grandfather clock and the window seat will come to good use. But by the light of Anne Frank's love of Priscilla Lane, I start to see the set as something else: a deepened interior, a recess of wood and plaster, carved into a hollow, a place where a sustained set of actions, all secretively contained in one spot, unfold in a concentrated period of time (fig. 41).

In that sense, the set of *Arsenic and Old Lace* evokes the theater *after* the play has ended more than before it has begun. The play over, the theater darkened, the set that before the show augured so clearly all that would happen now becomes mysterious, even sinister. We know what has happened in this space and yet the props and the space itself retreat as if made of shadows. Historians might wander the empty room, looking for the clues, and provide the solution, every prop having had a meaning as clear and coded as when we first beheld them upon taking our seats. But the emptiness of the set is what is really there to see. The story of the war now is less a matter of public symbols than of retired locations, withdrawn from the street, places that, even once discovered, retain their air of secrecy and violence.

My third example concerns the Russian ballerina Tamara Toumanova. I am invited to give a lecture at Rice University in Houston—it will be the first version of the talk that will grow into this book—and I note in preparation that the invitation asks that I discuss at least one work of art in the Menil Collection in that city. Having been sent a catalogue, I choose a work I did not previously know, Joseph

42

Joseph Cornell,
*A Swan Lake for
Tamara Toumanova:
Homage to the
Romantic Ballet*, 1946.
Box construction:
Glass-paned, painted
wood box with
Photostats on wood,
blue glass, mirrors,
painted paperboard,
feathers, velvet, and
rhinestones, 9½ x
13 x 4 in. The Menil
Collection, Houston,
gift of Alexander Iolas.

Cornell's box, *A Swan Lake for Tamara Toumanova*, made in 1946 (fig. 42). One of many pieces Cornell devoted to a ballerina he had met in 1940 and had seen in New York stage productions of *Swan Lake*, the box makes me think of Toumanova's one major film role of the 1940s.

In *Days of Glory* (1944), a film about the Soviet resistance (better than the previous year's *North Star*), Toumanova plays Nina Ivanova, one of a group of guerrilla fighters combating the Nazis. Cornell was a cinephile with a particular interest in the female stars of those years, and it is not difficult to imagine him breathlessly watching Toumanova in *Days of Glory*. Perhaps he even kept her film role somewhere in mind as he made *A Swan Lake* two years later. Says Toumanova at one point in the film, imaginatively reenact-

ing her character's prewar days as a ballerina in Moscow, "The footlights soft, the curtain is not yet up, and in my dressing room I'm half crazy with excitement. . . . I want to look my best tonight."

In *Days of Glory* Toumanova plays opposite the equally beautiful Gregory Peck, appearing in his first film, five years before *Twelve O'Clock High*. Director Jacques Tourneur makes much of the likeness between these two impossibly handsome black-haired persons, posing them side by side and letting them share some virtually slow motion kisses in an extended love scene (fig. 43). As the resistance leader Vladimir, Peck plays a character as tough as General Frank Savage in the later film. Vladimir will react with grim satisfaction to the destruction of a distant German aircraft they have been watching, whereas Nina responds with humanitarian sadness. But Vladimir and Nina then melt into each other's arms, murmuring dreamy protestations of love amid twinkling ethereal music. In 1949 films such as *Twelve O'Clock High* make history flow straight from a psychological jug of manly torment, but in 1944 the response to the war is a clasp of lovers.

Cornell's box is such a contrast to the Toby jug. It looks to be nearly weightless. Made of painted wood, glass, photocopies, mirrors, blue glass, painted paperboard, feathers, velvet, and rhinestones, it is small and delicate. Even the feathers, which establish the fetishistic airiness of the whole construction, redouble their lightness when reflected in the mirrors Cornell has placed on the sides and bottom of the box, as if seeking to lose even the little weight they have. The hefty earthenware vessel in *Twelve O'Clock High* spills a great whirlwind of historical recol-

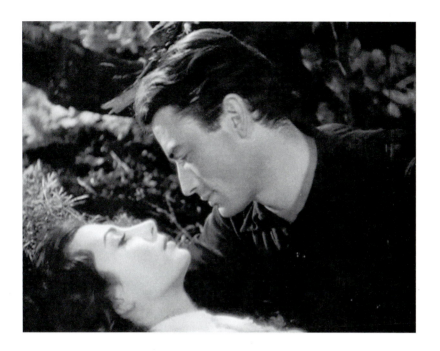

lection, the psychological innards of men who have lived dangerously, but *A Swan Lake for Tamara Toumanova* is like the breeze itself.

Cornell was or was not a historian. Culling secondhand shops for the occasional treasure, he was a connoisseur of the forgotten, a man driven by a passion for certain subjects (like the nineteenth-century Romantic ballet) that others did not much care about. The things he found, answering to his desire, would then allow him to make "reconstructions of a past he did not know." The lightness of the ballerina's steps guided the delicacy of his perceptions. Now imagine Cornell as Stovall. A dapper man looks in the window of an antique shop. What he sees, however, is not a big coarse jug but, say, little colored papers and folded cards, faded flow-

ers, a daguerreotype of an unknown person, a tiny packet containing maps of the moon.

Upon entering the shop, the dapper man sees that a swan's wing shares its curved line with the spread pages of a miniature dictionary. Such objects make him feel in the presence of a mystery whose terms he had not known until the moment they appeared in their unresolvable combinations. No wonder he asks that they be folded in swaths of blue crepe and packed "carefully, very carefully." The history he has discovered is over there, external to himself. It has no exact progenitor in the depths of his mind. Perhaps for that reason it hits him with the force of a revelation.

Hold Back the Dawn
Olivia de Havilland

Charles Boyer and Olivia de Havilland share an extraordinary kiss in the 1941 film *Hold Back the Dawn*. Boyer plays Georges Iscovescu, a Romanian gigolo residing in a hotel in a Mexican border town, waiting for a chance to cross legally into the United States. Emmy Brown, played by de Havilland, is a small-town southern California primary-school teacher guiding her students on a Fourth of July excursion to the town. Iscovescu, knowing that marrying an American is a ticket into the country, directs all his worldly powers of seduction at the naïve teacher. He quietly disables Emmy's car, insuring that she will need to stay the night, and the next morning approaches her in the 5 a.m. peace of the hotel lobby where she is surrounded by her sleeping charges. In lines written by Charles Brackett and Billy Wilder, he lays it on thick:

> We are like two trains halted for a moment at the same station, but we are going in different directions.

We can't change our course any more than we can hold back the dawn.

And then, after they have moved to the window, and having slipped a wedding ring on Emmy's finger as she slept, he holds her in his arms: "It is not this kiss I want. It is all your kisses. It is all your life."

They kiss, long and slow (fig. 44).

How does this kiss relate to 1941, the year when the movie was made (between February and early May) and released (in September)? For the two actors, the kiss was foremost a technical accomplishment. Boyer, a connoisseur, analyzed the topic clinically: "Differences in kissing are strictly individual idiosyncrasies and should be judged from that point of view. Thus when I kiss Paulette Goddard [the other star in the film] the technique differs considerably from the kisses I give Olivia de Havilland. The two ladies differ, so my technique differs." He defined the topic further: "Do you know what a kiss is? . . . A kiss is a touching of the lips in affection on the common ground of the two participants' habits and preferences, mingled in blissful congeniality." For her part de Havilland was a veteran screen kisser by 1941, notably with her frequent costar Errol Flynn, and she was as studied in the art as Boyer. On the set of *The Adventures of Robin Hood* (1938), she would retaliate against Flynn's flirtations by "flubbing kissing scenes, making them more passionate than needed, requiring retakes." In 1943 she conjured her first kiss with humorous detachment: "I was sixteen. I wore a pink dress. It was four o'clock in the afternoon. And it was in a prune orchard."

The world would need to vanish in the actors' concentration on the kiss. Even the set would have to disappear. Paramount's stage 10, scene of the kiss in *Hold Back the Dawn*, was too cramped a space to hold dozens of watchers, but there were many film-crew members there. It is possible that as they kissed Boyer and de Havilland were nearly as surrounded as Tyrone Power and Gene Tierney were while filming a kiss scene in the 1946 movie *The Razor's Edge*. A behind-the-scenes photograph in *Life* shows that kiss witnessed by fifty-one studio personnel, including assorted cameramen, prop men, sound engineers, and six electricians, plus, we are told in a caption, some thirty more employees who do not appear in the photograph. "Kissing on the screen is more than a romantic affair," Boyer said. "One has to consider such matters as camera angles, the

44

Iscovescu

(Charles Boyer)

and Emmy Brown

(Olivia de Havilland)

in *Hold Back the Dawn*

(1941).

lines one must speak when the lips part, and other purely technical things." Said de Havilland of her role in the film, using words that nicely describe her professional kiss, "I wanted to prove to myself that I could do a good job. It was really a matter of utmost importance to me." The two stars were extremely well compensated for the film—Boyer made $100,000 and de Havilland $70,000 for two and a half months' work—and the kiss was part of what the studio bought: a high level of skill, of technical craft, in the execution of challenging on-screen moments.

Part of the actors' skill was vanquishing their own bodies, let alone the distractions on the set, forgetting the frailties and ordinary rhythms of flesh and blood to get the technical kiss just right. "The closest I came to [a breakdown] was when I made *Hold Back the Dawn*," de Havilland told a fan magazine in 1943. She had recently undergone an appendectomy and gained twenty pounds, and she realized when she started work on the film in February 1941 that she had come back too soon after the operation. "I couldn't sleep at all, my hands shook, I couldn't remember my lines and I used to tremble violently at times." The kiss scene was part of this difficulty—shot in retakes across three separate days, from March 11 to 13, it was slow going partly because de Havilland, who had just missed six days because of sickness, was ill, upset, and moody, according to studio records. Boyer, for his part, had just missed a day because his stomach was "out of line" and one of the retakes of the love scene was caused when his toupee went askew during filming.

Yet you would never know any of this watching that consummately professional kiss. The actors overcome their physical discomfort, daily moods, and the public situation

of filming to achieve a moment of perfect intimacy. Aware of the cameras, conscious of their lines down to the last syllables, the last click of tongue on teeth, they conspire to produce a moment that forgets their studio surroundings, even their own bodies and emotions. And if that is the case, then surely the vast world at war and preparing for war must be absent as well. As Boyer put it in 1941, "Romantic pictures provide a necessary escape from the realities of this war-torn world."

How then do we regard the film's many references to the conflict raging in Europe and threatening more and more to involve the United States? Somehow these references are like the kiss. Words, words, words, not to be trusted, flow from the mouths of the characters, especially Iscovescu, as smoothly as the kiss. The viewer is seduced with a message about the times. Iscovescu, for example, is a conniving Europe sweet-talking a virginal United States. He is in Mexico because the war caused him to flee Europe, where he had spent his time in high-rolling locales in places like Paris and Biarritz. He got stuck at the border, denied passage because the American quota on Romanian immigrants had already been reached. He meets Emmy and starts seducing her on the Fourth of July. Emmy's students—all of them little boys—are rambunctious firecracker-throwing little rascals who take an instinctive dislike to snotty Iscovescu, whom they first meet as he wanders the border town, slovenly, unshaven, and aristocratically indifferent to the pro-American festivities. One of the boys tosses firecrackers at him, as if sensing his nationalistic disdain. Emmy, apologizing at first, says she hopes to avoid an "international competition" and later observes to Iscovescu, "I guess you don't

like us very much," and (after her car has broken down and she is forced to stay the night in town), "I promise you that we'll get back over the border as soon as we can."

But just before dawn the next morning, when the vigilant high-spirited boys are asleep, Iscovescu closes his trap for Miss America and moves in for the kill. With ruthless amoral precision he preys upon the provincial American school-teacher's goodness and innocence. She may be from Azusa, California, a place that "goes from A to Z in the U. S. A.," as she proudly says, but her small-town talk is no match for the limitless lexicon of the suave and alphabetically expansive Iscovescu. He can throw away vowels and consonants without worry, dispensing them as the occasion requires, because for a man without honesty new words will grow back like teeth in a magical serpent's head. His very name sounds like a scrambled spelling of the kisses he bestows, this Isco, Kissko, vescu. Emmy, spending the Fourth of July outside the United States, has never heard such language. Bosley Crowther of the *New York Times* wrote on October 2, 1941 that "one might, if one chose, make the point that 'Hold Back the Dawn' is a diplomatic contrast of American candor with European chicane. Possibly it is. But we rather think you will enjoy it as a straightaway romance." What Crowther did not see is that the diplomatic contrast *is* the romance. In 1941, seducing viewers meant taking their breath away with an enjoyable form of political communiqué—the United States was becoming involved with the world.

The seductiveness of war speech is never clearer than in the film's marvelously self-referential opening sequence. Iscovescu is shown wandering around the Paramount lot, hav-

45
Veronica Lake playing herself playing the singer Sally Vaughn in *Hold Back the Dawn.*

ing infiltrated a Seattle Kiwanis tour group, so that he can sneak onto a set and have a word with a film director he met in Nice. The director, played by Mitchell Leisen, the actual director of *Hold Back the Dawn*, is directing a scene from the military preparedness movie *I Wanted Wings* (Leisen's previous film, also released in 1941), as Iscovescu encounters him. On the set of *I Wanted Wings*—as shown in *Hold Back the Dawn*—we see Veronica Lake drawl into a telephone in a mock-up of a hallway (fig. 45) under the supervision of Leisen, playing the fictitious director Dwight Saxon. Lake's character in *I Wanted Wings*, the bad-girl singer Sally Vaughn, is on the phone seducing a wayward but good-hearted pilot, talking nice at first but then threatening him if he does not continue their relationship: "What does this

mean, goodbye, good luck, we've had our fun, you go your way, I'll go mine? Don't try to sell me that routine, Jeff."

The internal frame, showing the director's vantage, indicates that we are watching one film inside another—a little rectangle within a larger one—and that the aggressive sweet talk of Lake's character is a set-piece. In 1941 threatening come-ons achieve a formal clarity, and being behind the scenes to observe how the lovely and dangerous message is created only sets the viewer up more securely for being seduced by it. Lake's character tries to dissuade the pilot from his proper duty, but she embodies the come-on of war recruitment, rendered as a veritable poster of sequined glamour: I want you.

The persuasion happens in the midst of a larger patriotic message in *I Wanted Wings* about a military build-up. We do not see any more of *I Wanted Wings* in *Hold Back the Dawn*, but even this one scene helps establish the seductive power of war words in the follow-up film. *I Wanted Wings* opens with an extended sequence depicting a spectacular simulated air raid on Los Angeles, with a radio announcer narrating the true-falsity of this real-life unreal event in *War of the Worlds* style: "The attacking bombers are reported approaching the city from many directions. Parachute troops are being dropped on the outskirts." After a mock attack ensues and the planes have left, the announcer, orator of what did and did not really happen, intones reassuringly, "No homes have been shattered. No fires sweep the gutted streets of a burning city." It is all so real, though not true. Lake's intonations on the phone rhyme with the announcer's words into the microphone. She too protests that no harm is done, but

her wicked nightclub singer is a homewrecker. Propaganda for the coming war is a siren song.

Words in 1941 are and are not to be trusted, and in *Hold Back the Dawn* they flow most seductively from the lips of Iscovescu. Navigating the border between truth and fiction, skirting the doubled thresholds of movie studio and national boundary, he talks the dissimulating talk—Is this for real or not?—of 1941. After the director Saxon completes the *I Wanted Wings* scene with Lake, the crew breaks for lunch, and we go smoothly from Lake's to Boyer's way with words as Iscovescu sits down with Saxon to tell his true-life story, engrossing the initially reluctant director. In the original screen treatment, which Ketti Frings wrote in August and September 1939, basing it on the true story of her Austrian husband Kurt's efforts to immigrate to the United States, a fan magazine writer named Jennifer True approaches a producer on the lot. "Come on now," True tells the producer. "I'm going to show you a real story." In Brackett and Wilder's script, True becomes Iscovescu, played by Boyer, an actor we have just seen walking around the actual Paramount lot where the film was made, speaking to the actual director of the film, and in the tones of a frank confession. We are getting the real story, but of course not a word of it is true.

The film's story of European refugees is such sweet talk. *Hold Back the Dawn* "completely lacks understanding of, or else deliberately obscures, the truth about our official method of sorting our refugees by wealth, position and 'safe' political attitudes," wrote John McManus in his October 2, 1941 *PM* review. Noting the "plight of thousands . . . hating Fascism, yearning to breathe free," who yet must

watch "men of less integrity slip through our golden gates, which then clang quickly shut in the faces of the homeless and tempest-tossed," McManus upbraids *Hold Back the Dawn* for its mild portrayal of a good-hearted American immigration official keeping watch on the border and of the kind immigrants who wait patiently there: a Belgian professor, his wife and daughters, a barber, a pianist and his expecting wife. He notes that "in Cuba, in Mexico, in the concentration camps of France," oppressed people desperately hope to enter the United States and alludes to what another writer in 1941 called the "selfish fear," "lack of imagination," and "sheer ignorance" that cause many Americans to oppose admitting European refugees. In this context, McManus sensed the movie's subterfuge: "*Hold Back the Dawn* would have you believe that it takes bad lungs or a felonious record to keep an immigrant out. Don't you believe it." The movie's main point "seems to be that love conquers all, even the State Department." But, says McManus, "Don't you believe that either."

The title is a con, too. In this movie cowritten by the immigrant Wilder, who arrived in the United States in 1934, the phrase "hold back" is smuggled in nicely: the State Department patrols the border, holding back the flow of immigrants. But the politics of that phrase lead not to a political metaphor (as in "hold back the tide") but only to the romantic word "dawn." Putting that line in Iscovescu's mouth—"We can't change our course any more than we can hold back the dawn"—Wilder might have snickered at the sleight of hand conning ignorant viewers to accept hardline policy in the form of a love story. At a time when there was "little relaxation of the restrictions of our immigration

laws to meet the emergency," as a writer noted in 1941, when in fact "scores of measures to increase these restrictions and to render the lot of the alien and the exile more difficult have been introduced into Congress," the movie endorses bureaucratic restraint as the proper response to the refugee crisis. Romance is the lubricant for this paean to an unhurried humanitarianism and folksy adherence to procedure. The movie, like any movie, was surrounded by publicity, but more than most movies *Hold Back the Dawn* was itself a public relations exercise, a love letter from the State Department to American viewers, with Hollywood as the messenger. As a small-town review of 1941 put it: "The school teachers thought it very educational."

Pyrotechnics also made a convincing illusion in this romance of war. "Not for you a sudden flash that lights up your whole life," Iscovescu tells Emmy, guessing at the lack of passion in her life, urging her to grasp at "One split second to snatch at happiness before it is dark again." Later in the film we see flashes of nighttime lightning created by the Paramount technician Lee Zabitts, who got the desired effect by torching twenty pounds of powdered aluminum. The flashes, aided by a stream of oxygen and a six-foot reflector screen, were the equivalent of "3,000,000 candle-power of dazzling brilliance," visible "for miles around" on the outdoor set. They come attended by rumbling explosions that sound more like bombs than thunder. Zabitts was told that in the future he would need to find a substitute material, since powdered aluminum was already being conserved in early 1941 for war efforts, but the implication is that this expenditure of libidinal energy has been well worth it. The passionate emotions of the times light up

the world; love becomes extra volatile when the fate of the world is at stake.

No explosions mark the kiss, but it too occurred against a dazzling munitions backdrop. Coincidentally, on March 11, the first of the three days the kiss scene was filmed, Franklin Roosevelt signed the Lend-Lease bill, commencing enormous military aid to Great Britain, and asked Congress for the appropriation of a further seven billion dollars to assist the British. Upon news of the aid, the British Air Secretary Archibald Sinclair described "'fleets of airplanes' crossing the ocean and challenged Adolf Hitler to produce a secret weapon to meet this ever-swelling swarm," according to the March 12 *New York Times*. Like Emmy Brown, America was becoming involved with Europe. And in this context there was no going back; it was as futile to resist the war as it was to hold back the dawn.

The film's persuasion is so suave and relentless that eventually it appears to repent of the con it has foisted upon viewers. As if in compensation for the trickery, it searches for a panacea to ease the mind of even the most conscience-stricken publicist: a propaganda that tells the truth. A scene at the beach is this honest seduction, Emmy the seducer, her purity the persuader. She and Iscovescu have been on their honeymoon, and the question of when they will consummate their marriage is much in the air. In the Mexican village where they are staying, Emmy reclines in the back of their car and lets down her hair, but Iscovescu, plagued by guilt, pretends to injure his shoulder while setting the brake, creating a reason for them not to have sex. But then they go to the beach, and she spontaneously strips down to her slip and in the spirit of small-town innocence goes for

46

Emmy Brown

(de Havilland) in

Hold Back the Dawn.

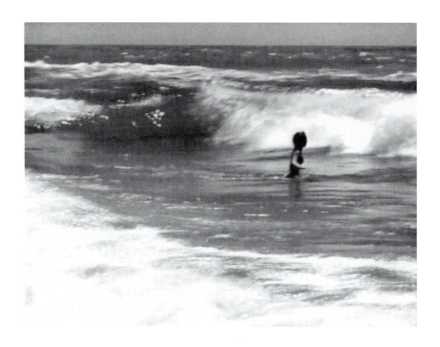

a swim in the chilly Pacific (fig. 46). Watching as she hails him from the surf, Iscovescu falls fully in love, his duplicity turned to truth. Never before has Emmy looked more pure and beautiful. She is honest as the ocean, true as the waves, and his own arrival in America is now a wholesome tide as fresh as the salt air on his appreciative face. When Emmy returns, wrapped in a towel, shivering and delighted by the cold water, Iscovescu kisses her passionately, their love consummated in this moment of purity.

The whole scene has a curious feeling of reality. Set in Mexico, it was shot on Hueneme Beach in the small town of Oxnard, California, forty-five miles north of the Paramount lot, and the on-location filming (rather than the fictional setting) is somehow the main point of what we see. Partly this reality secures a further subterfuge, to be sure.

The film aligns Mexico and the United States, aiming to establish a "solidified hemispheric stand" so that in a time of impending war Americans can "hold back the dawn in concert with our friends on this continent," as the Paramount publicists put it, and the filming of a California beach as a Mexican one is in keeping with this aim: their country looks like ours. But in another sense the vivid sunlight and crashing waves of the empty beach establish a coast, an actual coast, as a location of concern and great visual interest in those days of 1941. Although audiences would not have known what beach it was, or even that it was an American beach (so complete is the film's persuasive fiction), nonetheless it overwhelms with a sense of being a real place demanding the viewer's attention.

The emptiness of the beach partly establishes the feeling. Leisen closed the area, stationing a watchman down the road to intercept stray motorists, and in securing the place for filming he inadvertently gave the space a quality of restricted access that may not be expressly militaristic but accords with the general sense of an important and off-limits zone: authorized personnel only. It is maybe not a coincidence that once the war began, Hueneme Beach would be the site of bunkers and gun installations, and that Camp Rousseau, a U.S. Naval air base there, would soon post troops to guard against a potential Japanese invasion. Arthur Hornblow, the film's producer, notes in the press book for *Hold Back the Dawn*: "Nobody can say that the film industry is not doing its share for national defense," and in a strange way the film crew's shooting conditions at Oxnard demonstrated the point.

That real coastline makes the propaganda true. Emmy Brown, cavorting in the waves on the vulnerable coast, is the isolated American innocence that it will require a war to protect. What *will* hold back the rising sun is a romance of patriotism, America incarnate and lovely, chaste and hot, sensuous abandon in fifty-two degree water, a frolic of native pleasure guaranteed by every grain of undeniably real sunlight and sand. Even if ninety-nine crew members were on hand, and even if production notes call for a stunt swimmer and stunt diver—making it possible, even probable, that the woman in the water is not de Havilland—the wash of the real day and the real time, of a real person in the ocean, cannot be denied. The brightness of that actual day, when it appeared on screen, must have lit up gloomy theaters like the gospel truth.

The scene establishes a note of finality to the film's war persuasion. It was the last scene filmed, on May 5th, 1941—as if the duplicitous production needed to close on an honest note that compelled the belief of the actors and crew themselves. This was the actual American shore, one can almost hear them saying, and it was under threat. For the Hollywood types who traveled up from Paramount to this actual American place, Hueneme Beach was a boot camp, a retreat, the locale for a proverbial bonding experience—a place to reflect on all the real concerns that now, in the light of day, they could see their film had truly been about. The movie opened in late September 1941, and the first three small-town reviews of it in the *Motion Picture Herald* appeared in the December 6, 1941 issue. The next morning, the war began for the United States.

The kiss of Boyer and de Havilland should hold those months prior to Pearl Harbor. How it does so depends on how we think of sleep in the scene. In one sense, sleep here is oblivion. The boys doze all around Iscovescu and Emmy, who has herself been sleeping until she wakes to see Iscovescu before her. Maybe all this slumber is a Lethe Cup that turns the rest of the world just then to a drowsy inconsequence, in keeping with the world-forgetting technique of the actors. Maybe, too, it suggests a nation asleep.

In November 1941 a theater in Fairbury, Nebraska ran a promotion for *Hold Back the Dawn* featuring a young woman sleeping on a bed in a Montgomery Ward's department-store window. Passersby had to guess how many times she would twitch over a seven-hour period, from one until eight p.m. The stunt seems now an allegory of the weeks prior to Pearl Harbor, anticipating the title of Gordon Prange's 1981 book about the Japanese attack, *At Dawn We Slept*. Even the martial rhetoric of the promotion—a banner reading "How to Hold Back the Dawn from sabotaging your slumber"—seems part of the prewar snooze that does not know what sabotage is. So the sleep of the kiss on screen would portray a time whose chief characteristic is a lack of awareness.

But what if the trance of that kiss were a suspension of time? Then the sleep of the schoolboys would be a slow-motion ceremony of quietude, creating exactly the condition for the world just then to appear, for it to move through a place hushed as though for the purpose: the feeling of life just then, in 1941. If so, we would sense those months in the muted light of the hotel lobby, in the contours of the lovers' bodies, and even down into their mouths, where the

words of the day would disappear and these mouths would become, not the repositories and sources of viewpoints and statements, but rather caves holding the in-folded atmosphere of unspoken sensations.

And what would we see in that embodied hush? It is a personal matter. I happen to conjure a young woman on a bus, a copy of *True Story* magazine on her lap. She wiles the time, not noticing the blur of trees and department-store facades, the fences and pavements and red-brick corner bars and restaurants going by, but thinking her thoughts of the movie she has seen, *Hold Back the Dawn*, the kiss in it, a kiss that no doubt aspired to become part of her consciousness—for she is the target-audience, twisting her curls and minding her business. The kiss just then takes the form not of some romantic dream but rather of the advertisements in *True Story* that she'd been looking at and that now randomly like guardian angels start to float around her head, the ones for Admiración shampoo and Noxzema skin cream, Avaderma soap and Nujol ("Effective . . . Gentle . . . Regular as Clockwork")—these potions, lotions, and laxatives of love, haloed in their glass bottles, the liquors of melodrama whose smoothness is the same as the syrup she has seen on the screen.

Maybe, too, contemplating that kiss, allowing it to prosper and diffuse in these bottled creams and emollients, she will recall the feel of the theater as it still imprints her body, the worn plush of the seat, the sensation of the usherette's flashlight beam dancing down the aisle, the hard white plaster of the cup-lighted walls, the shiny tiles of the bathroom and the thickness of the wooden exit door as she held it open, maybe even the sedentary mass of the whole build-

ing, bricks, gravel, and glass, the projectionist astride it in his fireproof booth. At the theater these sensations took the shape of the candy she put in her mouth—that one-cent lozenge was the concentrated pill of the place from the marquee down to the elbow-joints of its plumbing—but now on the bus her experience has become the floating glass of her hygienic angels, the candied tonic of her guardian gods. Amid the exhalations of stale odors, the coughs of her fellow citizens, the dream of that kiss is sweet to suck on. There is nothing of consequence except that she has had these inconsequential thoughts.

And what of world events in this contemplation? In the tripled hum of bus, magazine, and movie, the threat of war is present, too. It does not take the form of a direct statement, or even an idle thought, though likely she has looked at the day's headlines. Instead it takes the shape of her body, of her being alive at that moment when we see her. This embodiment of the world does not happen when she moves through her conscious life, charting the day's activities, but rather in these moments of reverie, such as this one inspired by the kiss, when time pauses. Then political speeches on the radio, the rippled tides of Pacific islands, the fat Grumman Wildcats poised on the oil stains of their palm-tree airfields, not to mention the white-haired statesmen in Washington, D.C., with their pocket-watches and filigreed canes, welcoming diplomats in oak-paneled rooms hung with paintings of puffy-clouded skies above teams of oxen—then all of these visions gather as the wool of her coat, the shine of her black buttons, the pores of her skin, and the strands of her hair. Then too, by a contagion of reverie, the threat of war gathers in the kindred suspensions

144

of time she barely notices as the bus travels: the smudgy gleam of the silver handrails, the neon beer sign inverted in a puddle with a swath of night sky, an aureole of drowned cigarette butts for stars. None of these visions is an allegory, a statement of any kind, but a hush in which the world just then appears, suspended, without comment, condensed to a reflection. Thus might the kiss of Boyer and de Havilland be a medium holding that time even now.

Acknowledgments

I would like to thank the people who helped me to research and encouraged me to write this book. Marcia Brennan invited me to Rice University in 2008 to give the talk that became the basis for what I have written here. My editors at Princeton University Press, Hanne Winarsky, Brigitta van Rheinberg, and Alison MacKeen, successively oversaw the project with great professionalism and inspiring care. Kelly Malloy, Natalie Baan, and Donna Goetz, also of Princeton University Press, expertly helped with the details of publication. Anonymous readers of the manuscript provided insightful suggestions, as did my brother-in-law and always wise interlocutor, José Vargas.

I also thank Barbara Hall, Mark Quigley, and Erica Tinsley, and especially Ann Carter, Catherine Ladnier, Diederik Oostdijk, Mary Owen, Willys Peck, John Rampley, and Mark Swope.

Last, I am grateful to the students in my undergraduate seminars on the American home front and my graduate seminars on historical method at Yale University. Among the latter, I especially wish to thank for their conversations that I feel have related to this book: Mike Amico, Tess Korobkin, Henrike Lange, Conor Lauesen, and Eduardo Vivanco.

Bibliographic Notes

Alfred Eisenstaedt Eisenstaedt's brief account of taking the photograph is in Alfred Eisenstaedt, *Eisenstaedt on Eisenstaedt: A Self-Portrait* (New York: Abbeville, 1985), 74; see also Eisenstaedt, *Eisenstaedt Remembrances*, ed. Doris C. O'Neil (Boston: Little, Brown, 1990), 66. His photographs of tearful goodbyes at Pennsylvania Station are in "*Life* Visits Pennsylvania Station in New York City," *Life* (April 19, 1943), 92–97.

V-J Day Celebrations For the different coverage of the New York celebrations offered by *PM*, see "As New York Celebrated," *PM*, August 15, 1945, 8. For the violence in New York, see "V-J Revelry Erupts Again with Times Square Its Focus," *New York Times*, August 16, 1945, 1, 6. For the analogy between the celebration and the atomic bomb, see Alexander Fineberg, "All City Lets Go: Hundreds of Thousands Roar Joy after Victory Flash Is Received," *New York Times*, August 15, 1945, 1. For the accounts of mayhem in Los Angeles and San Francisco, see "Victory Celebrations," *Life* (August 27, 1945), 23.

The Flash For the moment of the atomic explosions, see "War's Ending: Atomic Bomb and Soviet Entry Bring Jap Surrender Offer," *Life* (August 20, 1945), 26; John Hersey, *Hiroshima* (New York: Bantam, 1981 [1946]), 1, 94; Fineberg, "All City Lets Go," 1. For the photograph as a nullifying explosion, see Eduardo Cadava, "Lapsus Imaginis: The Image in Ruins," *October* 96 (Spring 2001): 35–60.

The Aesthetic Moment De Quincey's account is in his great short essay of 1823, "On the Knocking on the Gate in *Macbeth*," in John Wain, ed., *Shakespeare: Macbeth: A Casebook* (London: Macmillan, 1968), 93. For one example of the suspended moment in twentieth-century literature, see E. M. Forster's short story "The Eternal Moment," in Forster, *The Eternal Moment* (New York: Harcourt, Brace, 1928). In Forster's story, a middle-aged Englishwoman, Miss Raby, encounters Feo, an Italian guide with whom she shared a romantic moment on an Alpine trip when they both were young. The long-ago experience, she now realizes, "had been one of the great moments of her life," vivid and world-defining, something that made the mountains where it happened "sit up like purple bears against the southern sky." For her, "the eternal remembrance of the vision had made life seem endurable and good" (235, 222, 235).

Belita Jepson-Turner Biographical information about Jepson-Turner can be found in the text accompanying the photographs: "Life's Cover" and "Speaking of Pictures . . . Ballet Dancer Goes Under Water in Hollywood," *Life* (August 27, 1945), 13, 15; also in Janice Gaines, "Some Fancy Footwork," *Milwaukee Journal*, January 30, 1944, Screen and Radio section, 6; in "Belita Was a Baby Ballet Star and Also Tops in Figure Skating World," *Milwaukee Journal*, June 15, 1946; and in Eddie Muller, "Belita: The Ice Queen of Film Noir," *Noir City Senti-*

nel (July/August 2009), 12–14. See also the fascinating television interview with Belita conducted in the late 1970s, where she recalled her time at the Olympics, among other subjects: http://www.youtube.com/watch?v=ffxll8MgoMl&context+ C3d44fbcADOEgsToPDskL9aTG5nmrCbUCMMdvIV7rB. More information about her great-grandfather G. W. Drabble is in H. S. Ferns, *Britain and Argentina in the Nineteenth Century* (Oxford: Clarendon Press, 1960), 333–34, 348, 384–86, 406–7, 411, 416–17.

Walter Sanders For Sanders's homecoming, see "The Road Back to Berlin: A *Life* photographer returns to a home and friends shattered by war," *Life* (November 11, 1946), 29–33. The quotation from "Hollywood Elegies" is in *Bertolt Brecht Poems 1913–1956*, ed. John Willett and Ralph Manheim (New York: Methuen, 1976), 380.

John Swope For the friendship of Swope, Stewart, and Fonda, and a good overview of Swope's first years in Hollywood, see Graham Howe, "An American in Hollywood," in *Camera over Hollywood: Photographs by John Swope, 1936–1938* (New York: Distributed Art Publishers, 1999), 11–20; for more of Swope's photographs, see the original publication *Camera over Hollywood* (New York: Random House, 1939). Mark Swope owns all of the Swope negatives for the photographs under discussion in this chapter.

Olivia de Havilland For the meeting of Stewart and de Havilland in December 1939 and their romance in California in 1940, see Gary Fishgall, *Pieces of Time: The Life of James Stewart* (New York: Scribner, 1997), 137–39, 148. For de Havilland's youth in Saratoga and the story of how she came to appear in Reinhardt's stage and film productions of *A Midsummer Night's Dream*,

see Charles Higham's biography, *Olivia & Joan: A Biography of Olivia de Havilland and Joan Fontaine* (Kent: New English Library, 1984), 24–36. See also the files on de Havilland at the Saratoga Historical Society Museum in Saratoga, California. Leisen's nickname for de Havilland, "Moonglow," is in Hedda Hopper, "Lovely Livvy," *Chicago Sunday Tribune*, December 1, 1946, 8, Olivia de Havilland files, Margaret Herrick Library, Beverly Hills, California. For the film prop, see "Moonbeam Weighing Half Ton Utilized in 'Dream,'" *Los Angeles Times*, October 19, 1935, A13. Regarding de Havilland and the staircase, I am grateful to Ruthie Dibble for making this observation. See also Jan Herman, *A Talent for Trouble: The Life of Hollywood's Most Acclaimed Director, William Wyler* (New York: G. P. Putnam's Sons, 1995), 311. At the end of the film de Havilland's character climbs the stairs unencumbered, the weight of her father and her conniving lover lifted.

For de Havilland's lawsuit, see for example, J. L. Yeck, "de Havilland vs. Warner Brothers: A Trial Decision That Marked a Turning Point . . . ," *American Classic Screen* 6 (May/June 1982): 34–37. For de Havilland's opinion of the different studios, see Hopper, "Lovely Livvy." Her joke on Sonny Tufts is described in "Olivia de Havilland at Last Plays the Comedienne She Actually Is," *Government Girl* press book (1943), n.p., Margaret Herrick Library. Her view of Swope's Marx Brothers humor is in "Livvy's List of Amusing Men," *Movies* (September 1940), 74. Olivia de Havilland files, Margaret Herrick Library.

Sound, Ephemerality, and Permanence See Jonathan Sterne, *The Audible Past: Cultural Origins of Sound Reproduction* (Durham, NC: Duke University Press, 2003).

James Stewart and Aviation Stewart's early interest in aviation, his World War II career, and his description of the thrill

of flying are in Fishgall, *Pieces of Time*, 77, 167–73, 91. The book contains many other accounts of Stewart and airplanes. The term "air-minded" is discussed in Joseph Corn, *Winged Gospel: America's Romance with Aviation, 1900–1950* (New York: Oxford University Press, 1983). The description of Tom Conway's fate is in Gene Youngblood, "Destitute, Says Tom Conway: The Falcon Roughs It," *New York Herald-Examiner*, September 14, 1965, 1, 8. The gift of an engraved propeller to Stewart is mentioned in Fishgall, 309. John Wayne also identified with the increasingly outmoded propeller days, as in *The High and the Mighty* (1954), where he plays a commercial airliner copilot and Air Force veteran down on his luck after a plane he was flying crashed on take-off, killing his wife and son. Given a chance to redeem himself when the airliner he is copiloting loses engine power on a flight from Hawaii to San Francisco, and when the young pilot (played by Robert Stack) cannot keep his cool, Wayne's character brings the plane (and the movie) to a safe end.

John Swope and Aviation Swope's aviation career is described in Craig Krull, "The Birth of Jupiter," in *"Bombs Away": Training for War; Steinbeck & John Swope Join Forces* (Salinas, CA: National Steinbeck Center, 1999), n. p. I learned about Swope's piloting also in a conversation with Mark Swope, June 15, 2011, in Santa Monica, California. See also John Steinbeck, *Bombs Away: The Story of a Bomber Team* (New York: Viking, 1942), and Carolyn Peter and John W. Dower, *A Letter from Japan: The Photographs of John Swope* (Los Angeles: Grunwald Center for Graphic Arts, 2006).

Olivia de Havilland and Aviation De Havilland's romance and breakup with Howard Hughes is described in Higham, *Olivia & Joan*, 60–61, 70–71, 74. For her opinion of *Report from the Aleutians*, see de Havilland, letter to John Huston, January

20, 1964, special collections, Margaret Herrick Library. For de Havilland's romance with Joseph McKeon, see Robert Matzen, *Errol & Olivia: Ego & Obsession in Golden Era Hollywood* (Pittsburgh: Goodknight Books, 2010), 183. For a thorough account of de Havilland aviation, see C. Martin Sharp, *DH: A History of de Havilland* (London: Airlife, 1982). Olivia's wish not to go about "with a long face" is in "Livvy's List of Amusing Men," 74. Her comments about a "spur-of-the-moment life" and the pleasures of impromptu flights are in Gladys Hall, "Livvy Doesn't Live Here Anymore," manuscript, 9–11, no publication information given, Gladys Hall Collection, Margaret Herrick Library. Was de Havilland herself a pilot? In 1943 the RKO publicity department reported that "Before the war Olivia took flying lessons and soloed once. She wishes now she had kept it up." (*Government Girl* press book, n.p.). For the death of Geoffrey Raoul de Havilland, see Sharp, *DH*, 305, and "Test Pilot Missing Jet Plane Blast: Geoffrey de Havilland, Son of Aircraft Builder, Had Hoped to Break Speed Record," *New York Times*, September 28, 1946.

Olivia de Havilland, Aviation, and Purity For the aviator in *To Each His Own* as a "supernatural being," see Martha Wolfenstein and Nathan Leites, *Movies: A Psychological Study* (Glencoe, IL: The Free Press, 1950), 133. The roles of de Havilland were not always pure. The lewd euphemisms in films of those years do touch her. In the Warner Brothers film *Wings of the Navy* (1939), she plays Irene Dale, a woman duty-bound to marry a fatherly flight instructor (George Brent) whose passion for airplanes leaves him few desires on the ground. When Irene meets the man's younger brother (John Payne), a cadet in training at the base, the two hit it off. Soon she and the young man are lounging in swimsuits on a platform far off shore, looking into each other's eyes. When Irene's fiancé then crashes his plane and suffers a crippling leg injury, the coast is clear. The emasculated instructor cedes the

field to his virile younger brother, who now really knows how to fly. In *Government Girl* (1943), de Havilland's character and her Washington boss fill the sky with bombers, and at one point take a euphemistically sexual motorcycle ride, proverbially zany and out-of-control.

Aviation and Cinema For the relation between propeller planes and films, see Robert Wohl, *The Spectacle of Flight: Aviation and the Western Imagination, 1920–1950* (New Haven, CT: Yale University Press, 2005), 3, 112–15; and Michael Paris, *From the Wright Brothers to "Top Gun": Aviation, Nationalism, and Popular Cinema* (Manchester: Manchester University Press, 1995), 7.

Olivia de Havilland and Her Later Movies For the poor critical reception of *Airport '77*, see Fishgall, 341; for *The Swarm*, see Robert Lindsey, "Olivia's Life Is Buzzing with Change," *New York Times*, undated [1977], de Havilland files, Margaret Herrick Library. Her views about seeing her old movies on television are in Don Alpert, "Olivia and 20 Million Frenchmen Can't Be Wrong about Television," *Los Angeles Times*, October 18, 1964, n.p., de Havilland files, Margaret Herrick Library.

Olivia de Havilland in Later Life For de Havilland as "spry," see "Academy Lauds Legend," *Variety*, June 20, 2006, de Havilland files, Margaret Herrick Library; "I'm old enough to be your mother" is in Kevin Thomas, "Her Return Engagement," *Los Angeles Times*, June 11, 2006, de Havilland files, Margaret Herrick Library. See also her arch sense of humor in an interview with a nervous reporter, Jack Dunstan, June 28, 1987, videotape, collection of Saratoga Historical Society Museum. Her presence at the unveiling of the statue of Geoffrey de Havilland, Sr., is in "Actress Pays Flying Visit to Honour Pioneer," *Times*, July 31, 1997, 5. She gives her answer to the question of how she would like

to die in "Olivia de Havilland," *Vanity Fair* (March 2005), 454. For de Havilland's recollection of attending a White House luncheon in 1940, see John Meroney, "Olivia de Havilland Recalls Her Role—in the Cold War," *Wall Street Journal*, September 7, 2006, D5.

Max Reinhardt's Departure from Germany For the story of how Reinhardt's *Midsummer Night's Dream* came to California, and how Reinhardt's production bears the mark of his experience in Berlin, see Gary Jay Williams, *Our Moonlight Revels: A Midsummer Night's Dream in the Theatre* (Iowa City: Iowa University Press, 1997), 176.

Olivia de Havilland's Youth in Saratoga I am grateful to Willys Peck for the time he spent showing me around his house and talking about Olivia de Havilland in an interview on April 4, 2011.

Olivia de Havilland, Sleep, and Remaining Untouched Even in her late 1940s roles, when she aspired to a greater realism, de Havilland seemed fated to portray characters out of touch with—if not actually asleep—to the world. In *The Snake Pit* (1948), she plays Virginia Stuart Cunningham, a woman with a mental illness who lives within her own universe of private paranoia and skewed logic. Mousy Virginia is cut off from others, not just men (whose advances she fears) but the other female patients in the asylum. In this film lauded for its realism, in which de Havilland brought all her skills to the empathetic portrayal of a victim of a psychological breakdown, it is ironic and fitting that she plays a person whose hallmark is *dissociation*. Bared to the quick in the film, her talent as an actress is to play a character who *cannot relate*. The actresses around her in *The Snake Pit*, each one playing a certain type of asylum inmate (the imperious,

the meek, the fun-loving, the doctrinaire), try to draw de Havilland's character out of herself, goading and egging her on, but without inflicting a single wound upon the glass perfection of her impeccably autonomous world. So did de Havilland's efforts to connect to outside circumstances—to the real world—only redouble her separation on screen. This untouchability, however, just *was* the social content of her best roles—their capacity to show her making it through dangerous places, Snake Pits, without harm.

This content, moreover, owes a deep debt to her "Moonglow" acting, her utter absorption in her parts. What she ultimately depicts, in her films, is the state of world-vanquishing concentration that she needed to achieve in order to believe in her roles. What we see on screen, in other words, is de Havilland portraying—with stunning accuracy—her technique as an actress: her ability to become absorbed in a role and then, a real stroke of genius, to make that absorption be the grounds for her belief and our belief in that character. To put it another way, she used the exacting but routine technical demands required of the actor—concentrating on her lines, heeding the director's words, elements that ordinarily compel our *dis*belief when we become too aware of them in a performance—as a way actually to draw us in. Her actor's absorption became a raw material that she fashioned into depictions of demure isolation, which offer believable pictures of persons impervious to the world around them. So it is in many of de Havilland's roles, not just her role as Virginia in *The Snake Pit*.

Margaret Bourke-White's Trip to Los Angeles Information about her itinerary comes from Morton Nathanson, letter to Margaret Bourke-White, April 19, 1943, Margaret Bourke-White Papers, Box 17, Special Collections, Syracuse University Library, Syracuse, New York. The route of the *Super Chief* is shown on

a map with an accompanying description in a document furnished to me by the California State Railroad Museum Library, Sacramento, California. Bourke-White's camera equipment in Los Angeles is described in detail in "Her Camera Equipment Amazes Even Opulent Hollywood!" in *The North Star* press book (1943), n.p., Margaret Herrick Library.

Bourke-White Goes Bombing In addition to the account offered in the article, "*Life's* Bourke-White Goes Bombing," *Life* (March 1, 1943), 17–23, see Bourke-White's description of the bombardier's reaction to her flashbulb and her own view of the bomber's "bookshelves" in *Portrait of Myself* (New York: Simon & Schuster, 1963), 229–30. For an account of the changing directives of American propaganda as the war went on, see George Roeder, Jr., *The Censored War: American Visual Experience during World War II* (New Haven, CT: Yale University Press, 1993).

Bourke-White and the Chrysler Building An authoritative account of Bourke-White's life, including her experience photographing the Chrysler Building in 1929–30 and her studio there in the early 1930s, is Vicki Goldberg, *Margaret Bourke-White: A Biography* (New York: Harper & Row, 1986). For Bourke-White and the Chrysler Building, see esp. 114–15 and 130. For Bourke-White's precise standards for her photographs, see Goldberg, 185, and Bourke-White, "Photographing This World," *The Nation* (February 19, 1936): 217–18. For Bourke-White's descriptions of the exhilaration of being up so high, see question-and-answer publicity release, ca. early 1930s, Bourke-White Studio, Bourke-White Papers, Box 1, Syracuse University Library. She describes her alligators in *Portrait of Myself*, 80. For the meeting with Mr. Schindall of Henry Schindall Associates, see Marjorie Follmer, letter to Margaret Bourke-White, February 12, 1965, Bourke-White Papers, Box 17.

Bourke-White, the Unbelievable, and Belief Bourke-White's account of the automobile as a "winged chariot" is in Bourke-White, "Photographing This World," 218.

Bourke-White and Aviation Bourke-White's work for International Paper is described in John R. Stomberg, *Power and Paper: Bourke-White, Modernity, and the Documentary Mode* (Boston: Boston University Art Gallery, 1998). See also Bourke-White's correspondence with International Paper, Bourke-White Papers, Box 23. When W. A. Delahey of International Paper's Maniwaki, Quebec offices informed the photographer that the company had renamed one of the lakes where she made her pictures "Lake Bourke-White," sending her a map noting the change, the photographer wrote back, "I can hardly tell you how delighted I am with it," saying her editors found the news "thrilling beyond words" and her friends "viewed it ecstatically" (Bourke-White, letter to W. A. Delahey, June 16, 1937). The extent to which Bourke-White took pleasure in turning the world into an image of herself is a topic worthy of study unto itself. Coincidentally, Bourke-White's work in the northern Quebec lakes took place on May 20–21, 1937, the ten-year anniversary of Lindbergh's transatlantic flight.

Bourke-White in Los Angeles For Bourke-White's time there, see Bill Henry, "By the Way," *Los Angeles Times*, April 26, 1943, A1 (about meeting with reporters upon her arrival); Hedda Hopper, "Looking at Hollywood," *Los Angeles Times*, April 22, 1943, A10 (about her impending arrival), May 4, 1943, 12 ("Gosh, What a Gal!"), and May 14, 1943, A15 (about Bourke-White's negotiations to make a film based on her life); Edwin Schallert, "Loretta Young Famous Photographer Choice," *Los Angeles Times*, May 12, 1943, 18; "Studio Briefs," *Los Angeles Times*, May 7, 1943 (describing a lecture she was to give on May 11 about Russia at

the Offices of Russian War Relief). See also Bourke-White, letter to Dorothy Flack, April 18, 1943, Bourke-White Papers, Box 17. Flack was the wife of the pilot Don Flack, who flew the B-17 from which she took her pictures of the bombing raid on Jan. 22, 1943, and Bourke-White wrote to Mrs. Flack, a resident of Los Angeles, inviting her to her lecture about the mission on April 26. The description of the autograph- and conversation-seekers on the set, and of Bourke-White's commando-like agility, is in William Hebert, "Margaret Bourke-White Goes to Hollywood," *Popular Photography* 13 (December 1943), 24. The photograph of Bourke-White in a swimsuit at the Town House pool is in the Margaret Bourke-White Papers, Personal Photographs Box 5.

The *Lady Be Good* The authoritative account from which I get my information about the plane, its crew, and its fate is Mario Martinez, *Lady's Men: The Saga of "Lady Be Good" and Her Crew: A Haunting Story of the Second World War* (London: Cooper, 1995). Quotations and facts in my telling of the story are from Martinez, 9, 31, 66, 88, 89, 144, 153, 154, 53, 140, 142, 8, 18.

The *Memphis Belle* For Wyler's work on the documentary *The Memphis Belle*, see Jan Herman, *Talent for Trouble: The Life of Hollywood's Most Acclaimed Director, William Wyler* (New York: G. P. Putnam's Sons, 1996), 255–57.

Ann Carter James Agee's views of "generalized" Hollywood and of "illimitable suggestions of meaning and mystery" are in *Agee on Film: Criticism and Comment on the Movies* (New York: Modern Library, 2000), 104, 152; Ann Carter, interview with the author, June 2011; Farber, "B Plus," *New Republic* (March 20, 1944), 381.

The *North Star* Hellman's tears are recounted in Scott A. Berg, *Goldwyn: A Biography* (New York: Knopf, 1989), 376. See also

Theodore Strauss, "The Author's Case: Post-Premiere Cogitations of Lillian Hellman on 'The North Star,'" *New York Times*, December 19, 1943, X5, and Brett Westbrook, "Fighting for What's Good: Strategies of Propaganda in Lillian Hellman's 'Negro Picture' and 'The North Star,'" *Film History* 4 (1990), 165–78.

Journeyman　The bad review, one of several of the play included in Bourke-White's files, is Brooks Atkinson, "'Journeyman,' from Erskine Caldwell's Novel, With Will Geer as a Traveling Preacher in Georgia," *New York Times*, n.d. [January 1938]. Bourke-White's belief that the play "should go in a big way" is in Don Mitchell, letter to Bourke-White, February 17, 1938. The sum of Bourke-White's investment, "a total loss" in the words of her certified public accountant Martin Mermelstein, is in Mermelstein, letter to Bourke-White, October 21, 1938. All of these documents are in the Margaret Bourke-White Papers, Box 24. The quotation about "future interest" is from William Troy, "Priapus in Georgia," *The Nation* (February 13, 1935), 194, a review of the Caldwell novel.

Bourke-White and the Moon　Bourke-White's youthful poem about the moon is in the Margaret Bourke-White Papers, Box 1. Her wish to be the first *Life* photographer on the moon is in *Portrait of Myself*, 383. For an excellent account of the relation between Bourke-White's work and that of Clarence White, see *Pictorialism into Modernism: The Clarence H. White School of Photography*, ed. Marianne Fulton, with text by Bonnie Yochelson and Kathleen A. Erwin (New York: Rizzoli, 1996). The account of the watches is MacLeish, "Bottled Time," *Fortune* (April 1930), 88–91.

"You, Andrew Marvell"　MacLeish wrote the poem before 1926; it was published in his book *New Found Land* (Boston:

Houghton, Mifflin, 1930). See Scott Donaldson, in collaboration with R. H. Winnick, *Archibald MacLeish: An American Life* (Boston: Houghton Mifflin, 1992), 167–69, 200–201.

On the Background of *Twelve O'Clock High* Harvey Stovall's conservatism when choosing a hat is in Beirne Lay, Jr., and Sy Bartlett, *Twelve O'Clock High!* (New York: Harper & Brothers, 1948), 1. For the filming of the Archbury sequence in Alabama, see the commentary of Alan T. Duffin included in the 20th-Century Fox 2007 DVD of *Twelve O'Clock High*. Duffin also notes that producer Darryl Zanuck cut out the female love interest in the story. In his own commentary, the film historian Rudy Behlmer notes how difficult it was to find B-17s for the filming of the movie.

Lifting Off as a Sign of Liberty, Ecstasy, Religious Ascension: A Note about William Faulkner Faulkner, himself an aviator and in Hollywood to write scripts, wrote a great take-off scene for *Air Force* (1943), directed by his friend Howard Hawks. In the scene, a B-17 pilot (John Ridgely) lies in his hospital bed, dying from his wounds in the early days of the war. His crew surrounds him, there to see him off. Delusional but at peace, the pilot imagines that he is at the controls ready for take-off, and mystically commands the crew to make the necessary preparations. The imaginary plane then ascends as the expiring pilot speaks of flying into the sunrise. In ways beyond the scope of this book, the scene hearkens to a recurrent theme in Faulkner's fiction—the person of weightless elevation as a lyrically inventive, ecstatic, and weirdly timeless figure. See for example Quentin Compson's story of the vaulting-fleeing French architect in *Absalom, Absalom!* (New York: Vintage, 1986 [1936]), 193, 176–77; the vision of the accidentally escaped convict upon a crashing wave of flood water as a swimming deer, lifted by the wave, runs on

water and then rises into the air, in *The Wild Palms* (New York: Vintage, 1990 [1939]), 148; and the weightlessness of the newspaper reporter "made of air," "intact of his own weightlessness like a dandelion burr moving where there is no wind," in *Pylon* (New York: Vintage, 1985 [1935]), 17, 172, 56, 226, 14, 174. I think too of Joe Christmas, in *Light in August* (New York: Vintage, 1985 [1932]), rushing past Mrs. McEachern and up the stairs to the attic: "He turned his head and his laughing, running on up the stairs, vanishing as he ran, vanishing upward from the head down as if he were running headfirst and laughing into something that was obliterating him like a picture in chalk being erased from a blackboard" (208).

Sentimental Mysticism For Agee's review of *The Clock*, see *Agee on Film*, 153. Agee goes on to say that the music accompanying the scene hurts it: "All this time, with the dirtiest and most merciless kind of efficiency, a full orchestra and hyped-up soprano are working at you, below the belt." For myself, I think the music adds wonderfully to the sentimental mysticism. For a prominent example of the visionary woman during the war, see Jennifer Jones's role as Bernadette de Soubirous in *The Song of Bernadette*, the huge hit film of 1943 in which she plays an adolescent girl at Lourdes who sees a vision of the Virgin Mary.

Letters to Donna Reed *A drenching rain*—Ed Tschippert, July 20, 1944, "South Pacific"; *Nightly downpour of New Guinea rain*—Robert Rolff, July 15, 1944, New Guinea; *front row of our makeshift theater*—John Summers, [South Pacific via] San Francisco, August 14, 1944; *Walked 2½ miles*—Fred Boose, July 2, 1944, New Guinea; *stood in six inches of rain*—Mitchell Williams, September 24, 1944, South Pacific; *50 yards away*—Rudy Robles, May 9, 1944, "somewhere in New Guinea" (Collection of Mary Owen, New York).

"Dreams of Movie Stardom"　The complete short story is in Anne Frank, *Anne Frank's Tales from the Secret Annex*, trans. Ralph Manheim and Michel Mok (Garden City, NY: Doubleday, 1984), 107–13.

Joseph Cornell and Tamara Toumanova　For Cornell and Hollywood film, see Jodi Hauptman, *Joseph Cornell: Stargazing in the Cinema* (New Haven, CT: Yale University Press, 1999). For Cornell and Toumanova, see Christine Hennessey, "Joseph Cornell: A Balletomane," *Archives of American Art Journal* 23 (1983), 6–12. For Cornell and history, see Thomas Lawson, "Silently, by Means of a Flashing Light," *October* 15 (Winter 1980), 49–60. Lawson describes Cornell collecting images "from which he was to make his reconstructions of a past he did not know" (52).

The Kiss in *Hold Back the Dawn*　Fred Hodgson, "The Loves of Boyer," in *Hold Back the Dawn* press book, 25, Margaret Herrick Library; the press book also includes "Diary of a Kiss by Charles Boyer and Olivia de Havilland," accompanied by five photographs showing the kiss in sequence (27). In "Questions of Olivia de Havilland," *Motion Picture* (November 1943), 37, 60, de Havilland describes her first kiss and tells how important it was for her to do well in *Hold Back the Dawn*, no matter how nervous she was on the set. Her anecdote about Errol Flynn and *The Adventures of Robin Hood* is in John Meroney, "Olivia de Havilland Recalls Her Role—in the Cold War," *Wall Street Journal*, September 7, 2006, D5.

The filming of the kiss between Power and Tierney is told in "*The Razor's Edge*: Story of a Single Scene Shows How Maugham's Novel Is Translated into a $3,000,000 Movie," *Life* (August 12, 1946), 75–83. The "cramped quarters" of Paramount's Stage 10, where the kiss in *Hold Back the Dawn* was filmed, are described in a note indicating that a number of scenes "could

not be shot as per director's requirements" (Ed Eberle, memo to Hans Dreier, April 19, 1941, *Hold Back the Dawn* files, Margaret Herrick Library).

The illness of de Havilland is noted in "Daily Production Report," March 21, 1941. Boyer's illness on March 10 and de Havilland's "change in . . . mood" on March 12 are noted in "*Hold Back the Dawn*, report on time lost," April 18, 1941. A report of de Havilland being taken ill on March 13 is in John Woolstenhulme, memo to John Zinn, March 14, 1941 (all from *Hold Back the Dawn* files, Margaret Herrick Library).

Kissing scenes caused problems with the mouth, de Havilland knew. Lucille Ball started stuttering during a "romantic dramatic moment" in the filming of *The Dark Corner* (1946) and was taken from the set to her home, where she remained inside for three months in a state of nervous terror about the mysterious stuttering, until de Havilland, hearing of Ball's plight, helped her rediscover her voice (Paul Rosenfield, "Compulsively Lucy," *Los Angeles Times*, October 12, 1986, T8, Margaret Herrick Library). Even speaking one's lines caused problems with the lips. On the set of *Hold Back the Dawn*, de Havilland noted that during their big scene together Paulette Goddard's "upper lip was trembling so badly I was afraid it would show on the film" (David Chierichetti, *Hollywood Director: The Career of Mitchell Leisen* [New York: Curtis, 1973], 172).

Hold Back the Dawn and the Impending War Boyer's opinion about "a necessary escape from the realities of this war-torn world" is in Hodgson, "The Loves of Boyer," 25. Bosley Crowther, review of *Hold Back the Dawn*, *New York Times*, October 2, 1941. Ketti Frings's story treatment, "Memo to a Movie Producer," with the line "I'm going to show you a real story," is dated August 5, 1939. Another document notes that she was assigned to the movie on September 11, 1939. A further treatment by Frings, still

called "Memo to a Movie Producer," is dated October 10, 1939. Brackett was hired on October 20 and Wilder on November 13, 1939 (see *Hold Back the Dawn* files, Margaret Herrick Library). The following year Frings published her novel *Hold Back the Dawn* (New York: Duell, Sloan and Pearce, 1940).

For *Hold Back the Dawn* and immigration, see John McManus, "Is It Love, or Is It Immigration?" *PM*, October 2, 1941, 19. A less perceptive but still interesting account of the film's treatment of immigration policy is Howard Barnes, "Hold Back the Dawn," *New York Herald Tribune*, October 2, 1941: the setting of the film "in a Mexican border town, where refugees from the Nazi-dominated countries of Europe wait hopefully and desperately for a chance to enter the country of freedom and opportunity," makes it "an absorbing commentary on the current refugee problem." The quotations about "selfish fear," "lack of imagination," and "sheer ignorance," as well as "little relaxation of the restrictions of our immigration laws," are from William Allan Neilson, ed., *We Escaped: Twelve Personal Narratives of the Flight to America* (New York: Macmillan, 1941), vii, vi. See also Gerhart Saenger, *Today's Refugees, Tomorrow's Citizens: A Story of Americanization* (New York: Harper & Brothers, 1941). For Wilder, immigration, and *Hold Back the Dawn*, see Ed Sikov, *On Sunset Boulevard: The Life and Times of Billy Wilder* (New York: Hyperion, 1998), 101–5, 151–55.

The technique of Zabitts is described in "How to Make Film Lightning Is Poser without Aluminum," in *Hold Back the Dawn* press book, p. 26. On American aid to Britain, and for Archibald Sinclair's quotation, see "President Signs, Starts War Aid; To Ask for $7,000,000,000 Fund Today; British Sea Losses Rise Sharply," *New York Times*, March 12, 1941, 1.

The filming at Hueneme Beach in Oxnard is described in an untitled Paramount publicity memo, May 22, 1941, *Hold Back the Dawn* files, Margaret Herrick Library. For the date and time of

filming—May 5, 1941, started at 7:30 a.m., finished 3:30 p.m.—
see "Daily Production Report," May 5, 1941. The report includes
a note: "Picture finished today 5/5/41." The report makes note of
a "swimming double" and a "diving double." A later untitled pub-
licity article by John del Valle, dated October 22, 1941, describes
de Havilland going into the water herself. For the allegory of
American-Mexican cooperation, see "Hold back the dawn with
our hemispheric friends," *Hold Back the Dawn* press book, 9.

Hold Back the Dawn and Pearl Harbor The December 6, 1941
issue of the *Motion Picture Herald* includes reviews of *Hold Back
the Dawn* from theater managers in De Leon, Texas ("Very fine.
Did extra business. Give it all you have"), in Au Gres, Michigan
("All who came were well pleased"), and in Dewey, Oklahoma
("pleased the women but not the men"). "The school teachers
thought it very educational" is from Mrs. H. A. Proulx, the man-
ager of the Au Gres Theatre. See "What the Picture Did for Me,"
Motion Picture Herald (December 6, 1941), 53.

The movie de Havilland worked on next after *Hold Back the
Dawn*, the Custer saga *They Died with Their Boots On*, has its own
relation to the war. Featured in the December 8, 1941 issue of *Life*
("Custer's Last Stand: 'They Died with Their Boots On' Glorifies
a Rash General," 75–78), it too portrays an imminent conflict, al-
beit with perhaps more ambivalence. Historian Richard Slotkin
contends that *They Died with Their Boots On* is largely an anti-
war film, portraying "war as something that fanatics and profi-
teers provoke but that principled and civilized soldiers seek to
prevent" (Slotkin, *Gunfighter Nation: The Myth of the Frontier in
Twentieth-Century America* [New York: Atheneum, 1992], 316).
As Libby Custer, de Havilland plays alongside Errol Flynn as
Custer, the two of them trying to defeat, in Slotkin's words, "the
machinations of American politicians, land-grabbers, and war
profiteers." Once the war began, however, "the culture's passage

from war-avoidance to mobilization is registered in the change in Hollywood's usage of western symbols" (Slotkin, 288, 316).

The movie de Havilland worked on prior to *Hold Back the Dawn* also alludes to impending war—specifically, the blustering rhetoric of those months in America and the resentment that such public declamation might cause. The film, *The Strawberry Blonde*, which premiered in February 1941, just as shooting on *Hold Back the Dawn* began, stars James Cagney as the impoverished turn-of-the-century dentist Biff Grimes, who looks into the mouths of his adversaries, pugnaciously exacting a comic revenge on the smooth and false talk of his social superiors: "What do you want me to do, tear out his teeth with my bare hands?" Grimes, a lower middle-class man, resents his lack of self-determination in a world where he is always told what to do, and his profession is his revenge. The light comedy allows his anger safe expression without diffusing it. The film depicts a grim fantasy, tooth for a tooth, in which the type of man who must do the bidding of others—getting set to fight a war, for example—wreaks havoc not so much on the speakers themselves as on their mouths, as if the mouth were the untrustworthy epicenter—the really hateful thing—of those weeks of 1940 and 1941 when the war (Should we fight in it? Should we not fight in it?) was all the talk.

The promotional stunt featuring the young woman asleep in the window is described in "Sleeping Girl in Window Tied to Contest on 'Dawn,'" *Motion Picture Herald* (November 15, 1941), 65. Gordon Prange, *At Dawn We Slept* (New York: McGraw-Hill, 1981). The coincidental fact that de Havilland was born in Tokyo, of all places, adds extra interest to the beach scene in *Hold Back the Dawn* as an expression of 1941.

Index